D0865583

IMAGES
of America

TULSA STATE FAIR

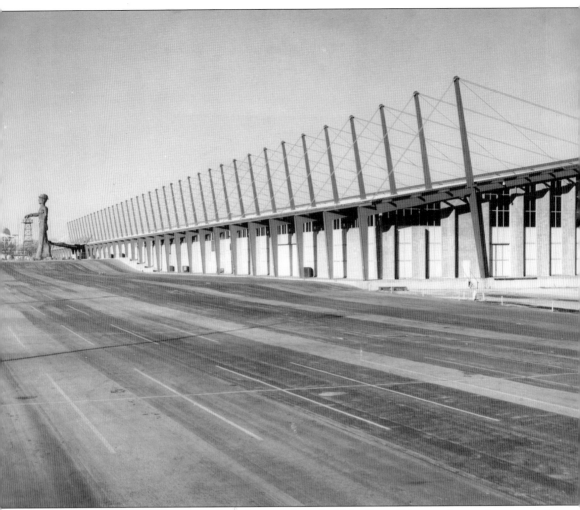

Many renovations and additions have been made to the Tulsa State Fairgrounds over the course of the years. The International Petroleum Exposition (IPE) Building, which is today's QuikTrip Center, took the fair to another level. The 400,000-square foot building allows vendors, competitors, and visitors the opportunity to see many of the different aspects the fair has to offer. The QuikTrip Center is used for other major events during the year, such as the Chili Bowl, the Tulsa Boat Sport and Travel Show, and the Tulsa Arms Show. (Courtesy Hopkins Photography Company.)

ON THE COVER: The Junior Livestock Auction began in the early 1950s and has become a long-standing tradition and experience for the participants and those attending to watch. The money benefits local 4-H and Future Farmers of America students in the advancement of their knowledge and furthering their careers in the livestock industry. (Courtesy Maurice Forrester.)

IMAGES
of America

TULSA STATE FAIR

Amanda Bretz

ARCADIA
PUBLISHING

Published by Arcadia Publishing
Charleston SC, Chicago IL, Portsmouth NH, San Francisco CA

Printed in the United States of America

Library of Congress Control Number: 2010925042

For all general information contact Arcadia Publishing at:
Telephone 843-853-2070
Fax 843-853-0044
E-mail sales@arcadiapublishing.com
For customer service and orders:
Toll-Free 1-888-313-2665

Visit us on the Internet at www.arcadiapublishing.com

CONTENTS

ACKNOWLEDGMENTS

This book was definitely an opportunity for me and was only made possible by the kind and informative people that contributed both photographs and their knowledge of both the fair and the fairgrounds. The retired and current employees of the Tulsa State Fair/Expo Square who have played such a large role in identifying numerous unidentified photographs are Paula Crain, Barbara Wood, Monte Cook, Joan Wyatt, Gerald Young, David Stine, Marilyn Denny, Tresa Tryon, Kara Eschbach, Brandi Herndon, Preston Jackson, Teresa Clayton, Jeff Talley, Amanda Blair, and Sarah Thompson. Linda Burrows, thanks for being my research buddy and keeping me informed of new information. A special thanks goes to the Tulsa Historical Society and local historian Richard Hackl for their contributions.

Unless otherwise noted, images appear courtesy of the Expo Square Collection.

INTRODUCTION

The Tulsa State Fair is often thought of as a once-a-year event that appears from out of nowhere, but in reality the actual historical and cultural impact that it has brought to Tulsa is not known by most. The people that have made this event what it is today are often unseen, and their stories remain unheard.

The local fair officially began in the late 1890s as a street fair located in downtown Tulsa. This event continued through the years until 1913, when the International Dry Farming Congress was established in Tulsa that allowed agriculturalists from all over the world a more appropriate place to gather. A 15-acre section of land north of Archer Street and Lewis Avenue was purchased and would be the home of the Tulsa State Fair for the next 13 years. In 1926, it was decided that a group needed to be established in order to make decisions over the new location that was built on a 240-acre lot that is now the present-day fairgrounds and Expo Square. This acquired land was mainly a donation from oilman J. E. Crosbie in 1923. The donation of the land was just the beginning of what would grow into one of the premier fairs in the country. The $500,000 bond issue in 1931 would provide the means to construct the art deco–style Pavilion and make other necessary improvements, which led to a 1935 legislation that elevated the small local free fair to state fair status.

Today's Tulsa State Fair is not only known for rides, food, and an exhibition of products and services, but anyone who attends the fair can tell it is a major livestock event that is one of the main draws associated with the fair. In 1949, the Tulsa State Fair merged with a spring livestock show to bring this new event to the fair. Education and entertainment are combined with all of the livestock competitions. This allows for educational attractions and an all-around family atmosphere.

The animals were such a positive addition to the fair that years later the Professional Rodeo Cowboys Association would attend the fair. This long-standing competition between cowboys would thereafter visit Tulsa on a yearly basis.

In 1966, the International Petroleum Exposition (IPE) Center was built and made into a major part of the fair. Known as one of the world's largest freestanding buildings, the Tulsa Fairgrounds was the new home to the International Exposition for 13 years before being cancelled after 75 years due to a downturn in the oil industry. The building remains as a part of the fairgrounds and as a special part in history, but as time goes on it is important that the grounds be updated and improved.

During the 1970s, updates were made and year-round marketing began around the complex. It was at this time that the fairgrounds were renamed Expo Square. Updates were made throughout the Pavilion, and a 13,000-seat grandstand was built. Expo now hosts hundreds of events each year, with the Tulsa State Fair being the only one that Expo Square produces itself.

With years of history that represent the heart of Tulsa, through the days of booming oil to the memories and history of the fair, there is truly something unique and special. From the famous *Golden Driller* to the food-on-a-stick creations, the Tulsa State Fair has a history that is just waiting to be revealed.

One

FACILITY DEVELOPMENT

In 1923, the Tulsa Fairgrounds were moved to a portion of land between Fifteenth and Twenty-first Streets located in midtown Tulsa. The land was developed in order to produce what would become one of the top fairs in the nation. The development began at this time, but it would have many renovations, expansions, and improvement projects in order to maintain the grounds that have brought so much history and success throughout the years.

The vision of a full building complex was imagined in the mid-1920s, and in 1931 the Pavilion was built to begin this initial plan. The first fairs that existed on the current grounds were housing exhibits and displays in rented circus tents.

The building projects were successful throughout the years with additions such as the grandstand, Exchange Center, Livestock Complex, and the International Petroleum Exposition in 1966, which would bring a new type of marketing to the Tulsa Fairgrounds.

The most recent facility development project occurred with the capital improvements project by the 4-to-Fix the County and Vision 2025 programs. Expo Square was seen as one of the critical areas to make improvements on. With the complete reconstruction of the Exchange Center, barn improvements, and the new Central Park Hall, Expo Square has become a leader in not only events complexes, but it also has one of the top state fairs in the nation.

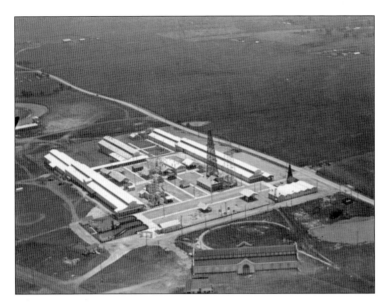

This 1926 aerial view shows the fairgrounds at its very early stages. Tulsa was in the peak of its oil and natural gas production, and the fairgrounds are showing its claim to fame in this photograph, with the oil derricks centrally located on the grounds. This was only the beginning of the expansion that occurred in the next couple of years. (Courtesy Richard Hackl.)

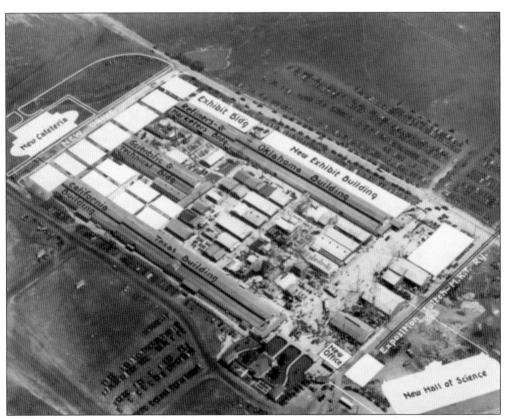

The labeled structures are previous buildings that were standing through the 1950s and 1960s, with the white spaces documenting where buildings were to be placed in the future. These buildings were off limits to any fair usage and were strictly meant for the International Petroleum Exposition. (Courtesy Richard Hackl.)

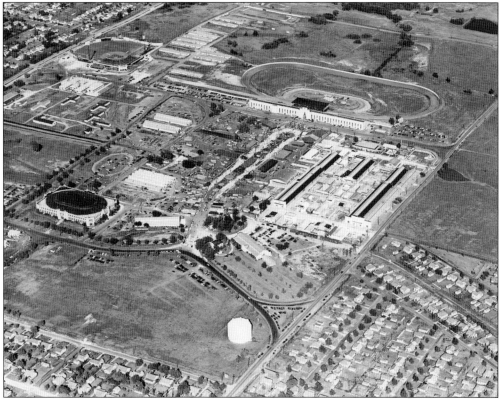

This 1949 photograph shows the fairgrounds pulling back into business after the struggle that occurred from World War II; 1941–1943 left the fairgrounds at a standstill due to harsh economic times. The fair reopened its doors in 1944, but only for a livestock event. The fair came back to Tulsa in the late 1940s to bring back the much-missed rides and attractions that had disappeared due to gas rationing in previous years. (Courtesy of Aerial Photo Service.)

The 1949 Tulsa State Fair office was located on the west end of the midway, where the modern-day security building now stands. This converted house was made into the main office and housed employees such as Clarence Lester, the Tulsa State Fair general manager at that time.

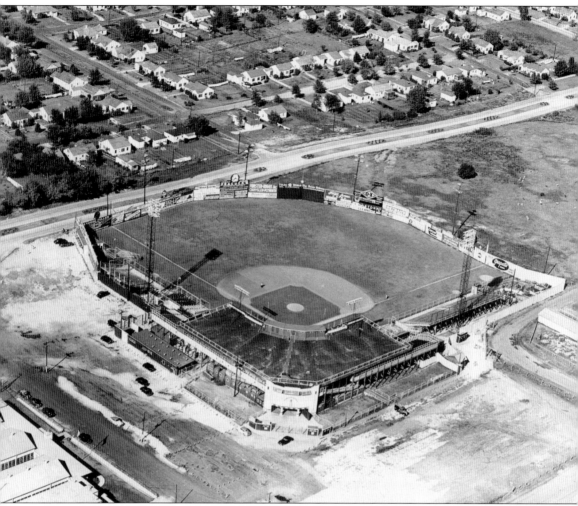

Oiler Park was located just west of the corner of Fifteenth Street and Yale Avenue. The stadium opened its doors in 1934 to begin what would be a long, successful history. The Tulsa Oilers held a long-standing history in the Texas League. The Oilers were a minor-league affiliate of teams such as the Cincinnati Reds, the Philadelphia Phillies, and the Cleveland Indians. The Oilers received their big break when the St. Louis Cardinals signed the team in 1959 to a seven-year player-development contract. In 1966, the Drillers went from Double-A to Triple-A status and moved to the Pacific Coast League. Oiler Park relived history in 1977, when the stadium collapsed—just as the original stadium did in 1910. Oiler Park was no longer, but Driller Stadium moved to the 15th and Yale location in 1981, where it was used until 2009. (Courtesy Aerial Photo Service.)

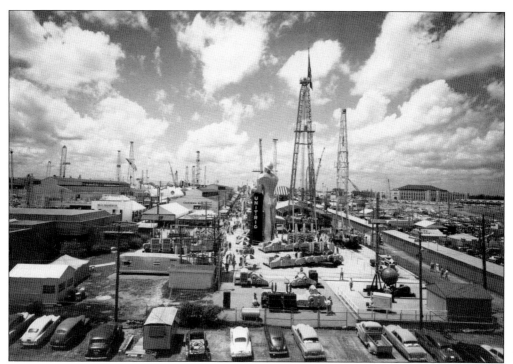

This 1952 photograph shows the International Petroleum area, which includes buildings named after Oklahoma, California, and Texas. The oil rigs are also set up along with a "Driller" that can be taken down. It wasn't until 1966 that the *Golden Driller* was moved to its permanent location.

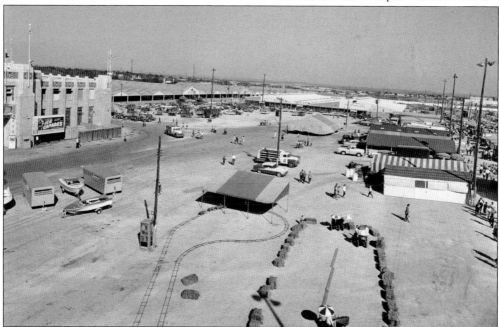

The 1952 midway displays the dirt and the setup of the tents. Carnival rides are on the east end of the midway. The background shows the dormitories used by the 4-H students while they worked at the fair. (Courtesy Jim Boatright Photography.)

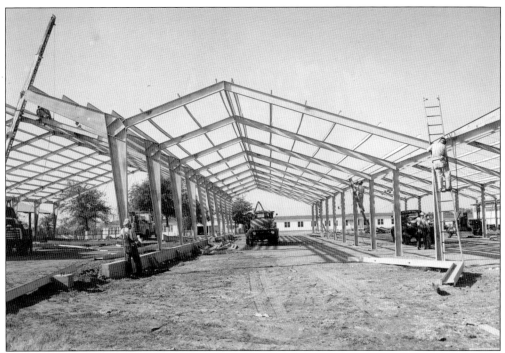

The barn construction began in 1952 and lasted until the late 1950s. The Livestock Complex would become a major component of the fair. Over the next 50 years, the livestock barns would have several renovations and additions. In 2003, the second phase of 4-to-Fix the County was completed and included two new free-span livestock barns. The Vision 2025 project allowed for two more livestock barns on the grounds in 2004. The livestock complex now host events such as the National Arabian Championship, the Pinto World Championship Horse Show, and the American Miniature Horse Registry. (Below, courtesy Bob McCormack Photographic Studio Archive, Department of Special Collections and University Archives, McFarlain Library, University of Tulsa.)

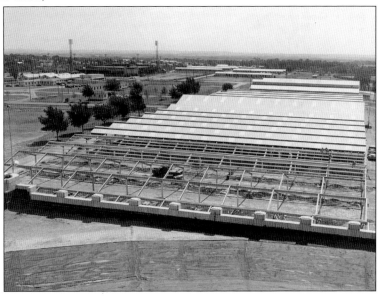

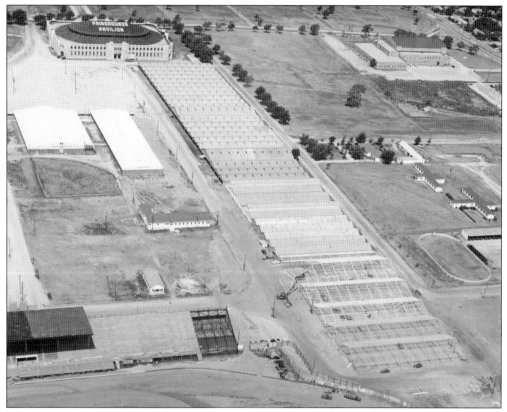

This 1955 photograph shows the continuation of the barns. As time has progressed, livestock have brought many events to Tulsa that have created economic growth. The fair brought livestock events out to the fairgrounds, and as facilities were built to host opportunities, events became larger. This included beef, dairy, and outdoor exercise arenas, and there were a total of 800 stalls available. (Below, courtesy Aerial Photo Services.)

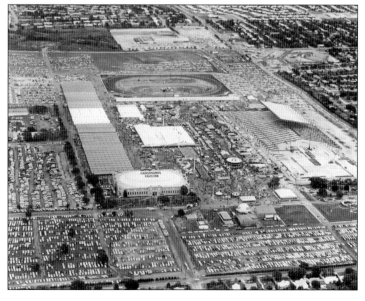

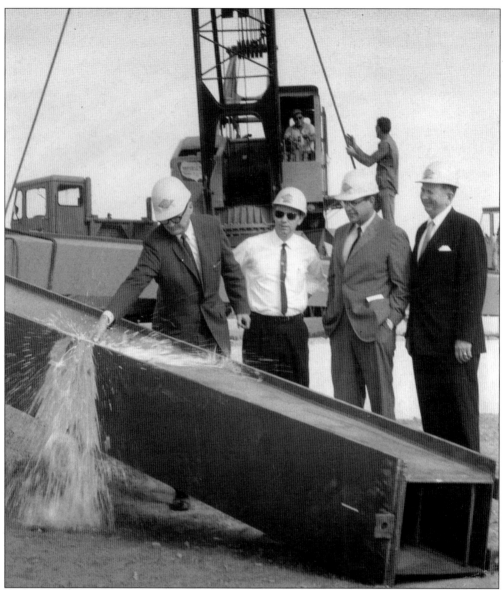

Clarence Lester, general manager of the Tulsa State Fair, christens the International Petroleum Exposition Building. Although the IPE had been in Tulsa since 1930, it wasn't until the mid-1960s that it decided to construct the building that is now a part of history for Tulsans. All other IPE buildings were demolished, and in 1966 the new IPE Building became the new headquarters.

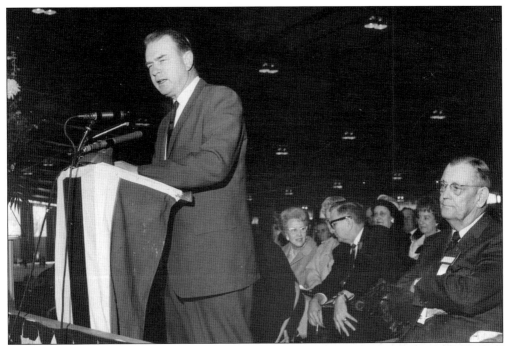

Gov. Henry Bellmon speaks at the dedication of the IPE Building. R. K. Lane is seated behind Bellmon, and Clarence Lester has his head turned.

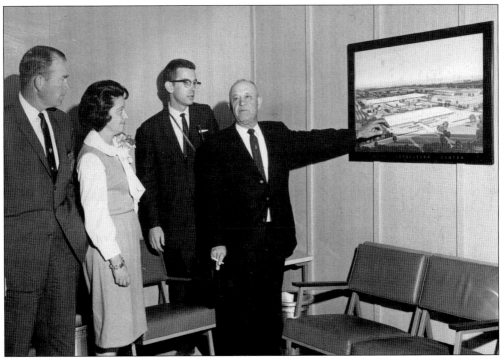

From left to right are Gov. Henry Bellmon, Mrs. Bellmon, Tom Tate, and G. C. Parker at the dedication of the IPE Building. The IPE Building covered nearly 10 acres and at one time was the largest free-span building in the world.

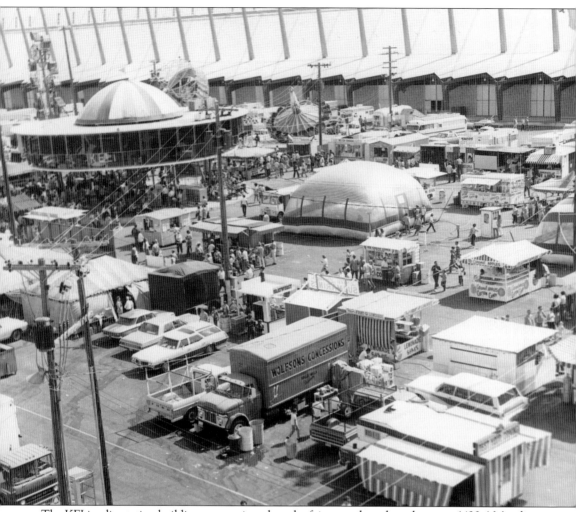

The KELi radio station building was stationed on the fairgrounds and was home to 1430 AM radio. All the DJs went by radio names and the first DJs to go on the air went by the last name Kelly. When a person tuned to KELi, he or she could expect nothing but the popular 1960s rock-and-roll hits. The station always played an active part in the Tulsa State Fair from live broadcasts to participating in the Tulsa State Fair annual parade. (Courtesy Bill Akers Photography.)

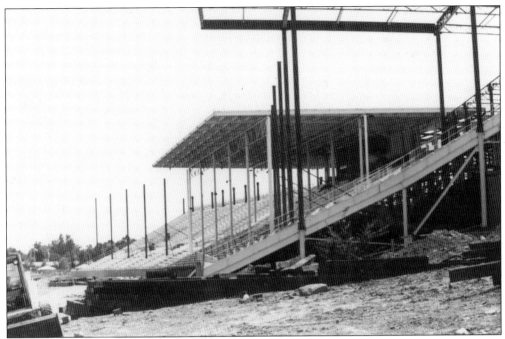

The new grandstand was built in the mid-1970s and was used for everything from concerts to the tractor pull and races. The 13,000-seat grandstand still stands today, but it is primarily used for the Fair Meadows horse races. Concerts held in the Tulsa State Fair Grandstand included performances by Willie Nelson and George Strait.

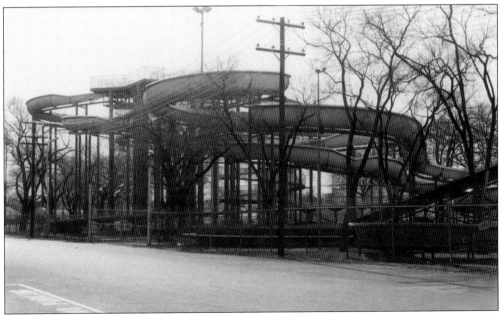

Big Splash Water Park opened its doors in 1982 and has remained a part of Tulsa summer fun. Big Splash rents its location on the corner of Twenty-first Street and Yale Avenue from Expo Square. The water park is known for its wave pool and also has a large area dedicated for young children.

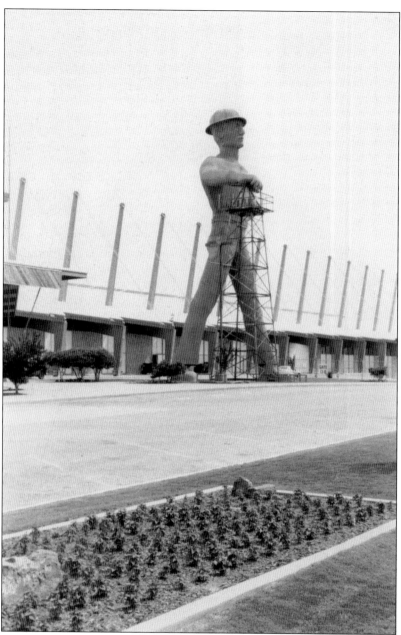

The *Golden Driller* has become an icon for not only the Tulsa Fairgrounds but for Tulsans as well. The "Driller" is the second most popular visiting spot for Tulsa tourists. The Driller was first introduced in 1953 at the International Petroleum Expo by Mid-Continent Supply Company of Fort Worth. With the Driller receiving so much positive attention, the site of the IPE Building became the permanent home for the *Golden Driller* in 1966. Built by the Boone Company, the Driller is one of the largest freestanding statues in the world and weighs in at 43,000 pounds. It is 76 feet tall, has a 48-foot-wide belt, and wears a 393-DDD shoe and a size 112 hard hat. At his right stands an old oil production derrick that was moved from an oil field in Seminole, Oklahoma. The local icon has withstood weather, tourists, shotgun blasts, attacks by vandals, and even being shot in the back with an arrow.

Bob Dick played a large role in the 4-to-Fix the County program, which voters twice approved in the form of a tax increase that would support Tulsa County criminal justice, parks, Expo Square, and county roads. The Expo Square portion was split into four phases that would focus on different areas for each phase. Updates and renovations were made all over the complex, and additions were made in the form of Central Park Hall, two new free-span livestock barns, and a new Exchange Center.

Denny Tuttle spent 32 of the 54 years of his life at Expo Square and the Tulsa State Fair. Starting in the accounting department in 1974, Tuttle worked his way to chief financial officer and later to assistant fair manager. Tuttle was promoted to chief executive officer in the early 1990s, a position he held until his sudden death in 2006. Denny was involved in many different areas and worked constantly to improve Expo Square and the Tulsa State Fair. He was the president of the Midwest Fairs Association and a leader in his field. Tuttle worked hard to achieve the 4-to-Fix the County project and believed Tulsa could benefit through continuing efforts at Expo Square.

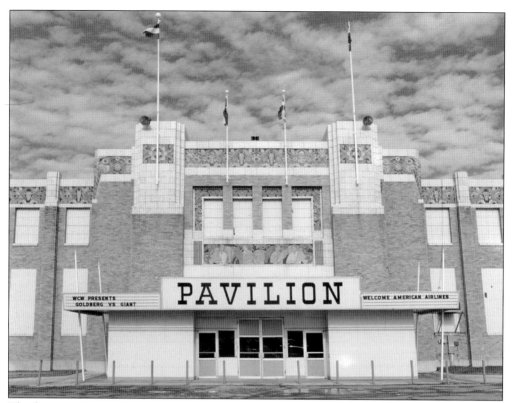

The first major construction project at the fairgrounds was the building of the Pavilion in 1931, which was made possible through a $500,000 bond. The 5,000-seat arena was developed as a multipurpose building. It can be used as an ice-skating rink, rodeo arena, concert hall, or banquet hall. The Pavilion was designed with an art deco theme, which has been carried through the grounds. The terra-cotta roofline features a vibrant pattern of flowers and livestock heads. Pictured below is a sign from the 1970s. The Esplenade and Central Park Hall have also been constructed to show this particular style. The construction price of the Pavilion in 1931 was $267,000.

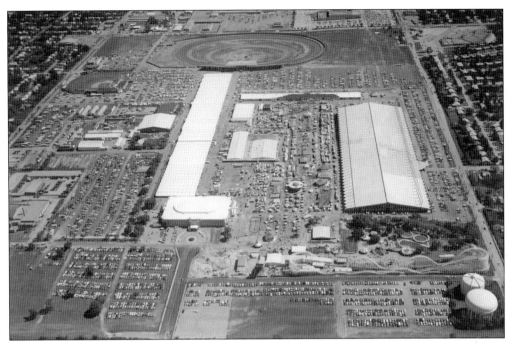

The 1970s brought new changes for the fairgrounds. The Tulsa County Fairgrounds Trust Authority was formed and took over the fairgrounds operation in July 1970. Management of the facility was changed as the new, nine-member authority assumed control. With the new authority, there came a new responsibility of more than $5 million in fairground improvements. The new 13,200-seat grandstand was constructed, along with air-conditioning for the Pavilion and Exposition Center, modernization of the Pavilion, construction of the North Arena, and reroofing of the Exchange Center. It was also during this time that the complex was renamed Expo Square.

The 1980s brought way for additions such as Driller Stadium, which would move to the corner of Fifteenth Street and Yale Avenue. Big Splash Water Park would open its doors in 1984. The rodeo made its debut at the fair and became an instant success, leading to its recurrence as an annual event.

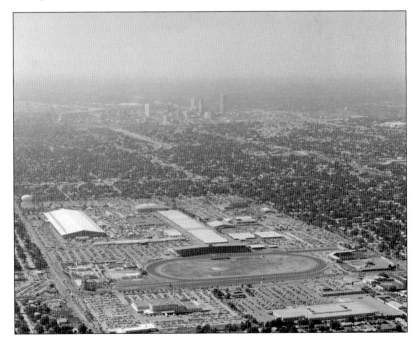

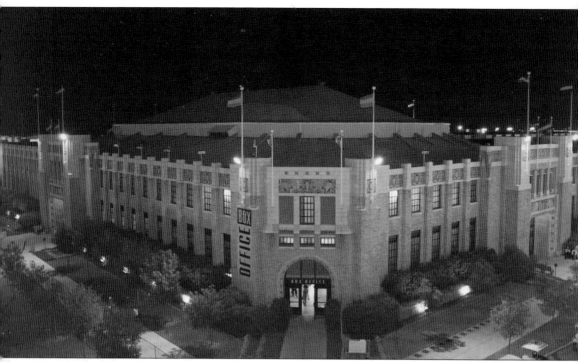

A 2009 view of the Pavilion shows the updates that have been made over its 78 years of existence. The Pavilion has updated its facilities to include its own ticket office that produces and sells event tickets. In 2008, the Pavilion arena floor size was expanded, along with an increase of space on the north side and the addition of a green room and loading dock. (Courtesy Cooper Designs.)

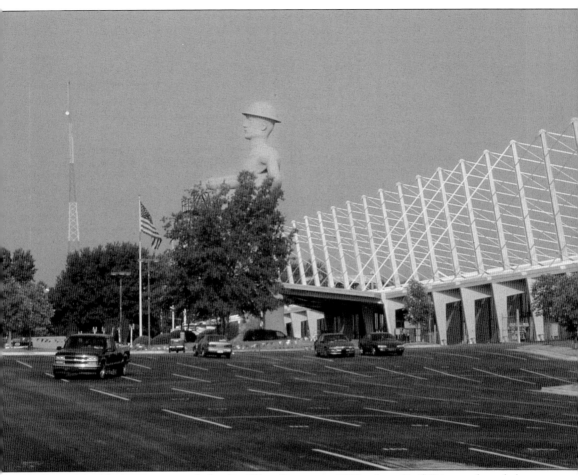

The IPE Building was renamed the QuikTrip Center in 2007, when QuikTrip purchased the naming rights with a 10-year contract. With the assistance from 4-to-Fix the County and Vision 2025, improvements were made from 2003 to 2008. The QuikTrip Center currently has 398,080 square feet of usable space. (Courtesy Cooper Design.)

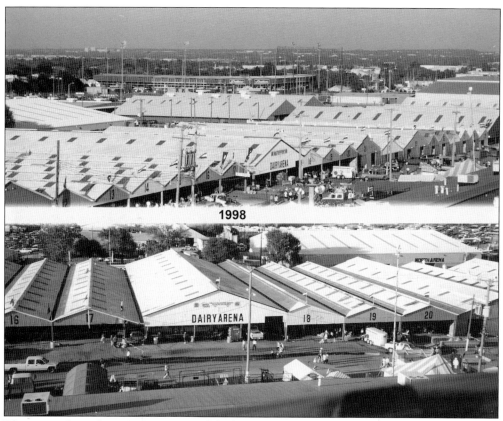

1998

The image above shows a comparison of the livestock barns in 1984 to the present-day Livestock Complex, pictured below in 2009. The changes that have occurred over the years have earned the complex national recognition and have led the Tulsa Fairgrounds to be one of the top facilities in the nation. As of 2008, there are four permanent arenas along with the capability to set up additional, temporary arenas. (Above, courtesy Richard Hackl; below, Cooper Designs.)

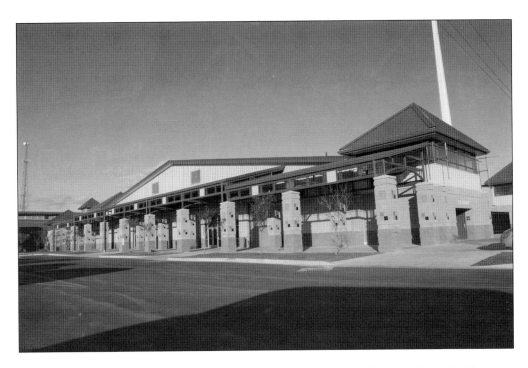

The Exchange Building has 58,500 square feet of free-span space. The brand new building was opened in September 2008 and holds the "Made in Oklahoma" portion of the Tulsa State Fair. The event facility consists of three meeting rooms and two show offices. Since the building's completion, events such as gun shows, banquets, markets, and even livestock events have made their home at Expo Square. (Both courtesy Cooper Designs.)

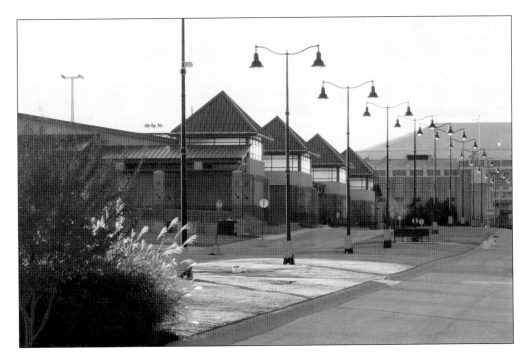

Central Park Hall opened its doors in March 2008. The brand-new two-story 43,000-square foot building features meeting rooms both upstairs and downstairs, as well as a ticket office and a mezzanine that overlooks the entire bottom level. Central Park Hall is used as the "Just for Kids" building during the fair, and during the year it is used for a variety of events. (Both courtesy Cooper Designs.)

Two

ATTRACTIONS
PAST AND PRESENT

The Tulsa State Fair is known for having a full lineup of family entertainment. There will always be new entertainment to keep with the changing times, but there is a history of traditional entertainment as well.

The first fairs began with carnival rides, agricultural exhibits, floricultural shows, animal shows, and many other shows that catered to educating the public. These exhibits remain today, along with new entertainment that includes music, stage shows and different forms of competitive exhibits and competitions.

Whether fairgoers attend the classic livestock events or see the new grounds shows, the attractions of the past and present give the Tulsa State Fair the entertainment that everyone is looking for.

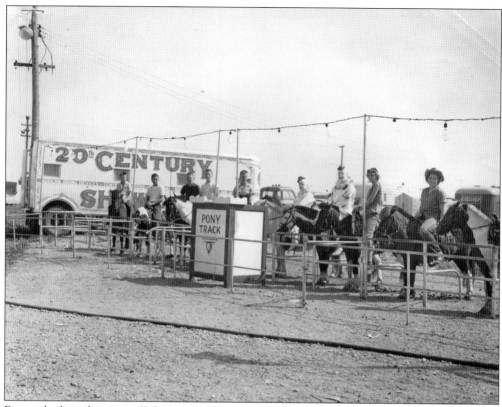

Pony rides have become a Tulsa State Fair tradition. This 1950s photograph features a lineup of the pony track. Livestock events give everyone an opportunity to see the animals, but the pony rides have always given children the opportunity to ride the animals.

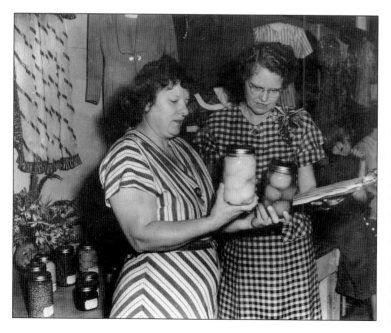

Two women judge a competitive exhibits competition. From jam to pickled vegetables, the competition allows men and women to prepare their traditions and compete against other locals in hopes for the blue ribbon. This friendly competition has always allowed for fun and bragging rights as one of Tulsa State Fair's best.

Mad John the Mechanical Man was is the entertainment seen here during a 1950s Tulsa State Fair. His sharp, mechanical motions made the actor appear to be a robot. The Tulsa State Fair has always tried to find entertainment that is different to keep fairgoers guessing what will be there the next year.

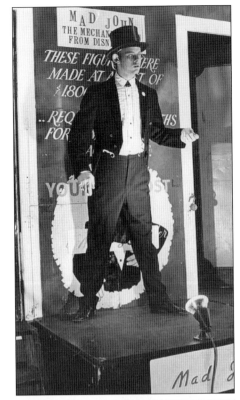

This photograph shows the 1952 Satellite Studio Fair Parade. The annual fair parade was on the first Saturday of the fair and occurred until the early 1990s. This float shows the KELi 1430 radio station in front of the Pavilion. KELi always made its presence at the fair, and the parade was just one example.

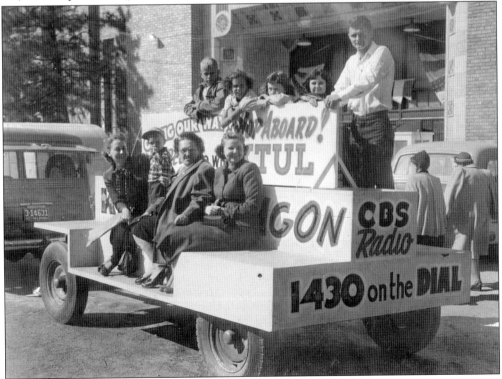

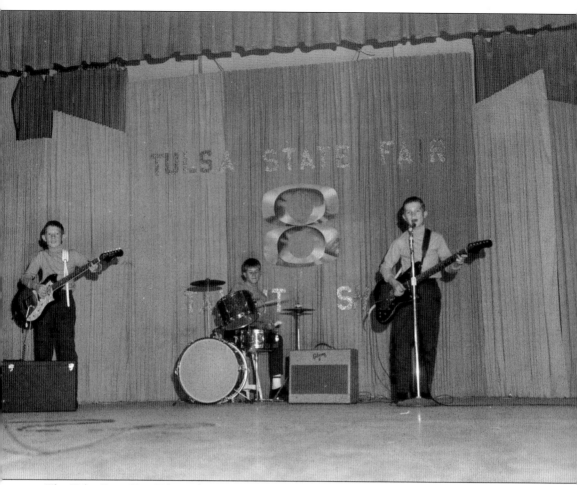

The Tulsa State Fair Talent Show was a must-see at the fair. Hosted many years by Betty Boyd, this traditional event was filled with local talent that included singing and dancing acts as well as others. Hundreds of entries were submitted into each division of the talent show. Winners would receive a trophy and also the honor of being one of the Tulsa State Fair Talent Show winners. The talent show lasted almost 20 years before coming to an end; big costs and smaller budgets led to its demise.

The Tommikejimike folksingers proudly display their winning trophy for the senior amateur division in the 1965 talent show.

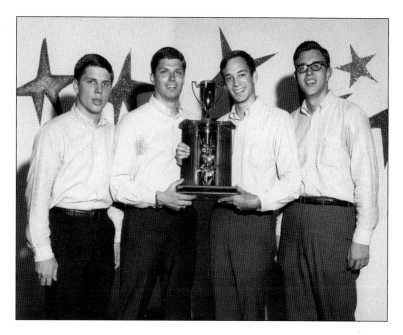

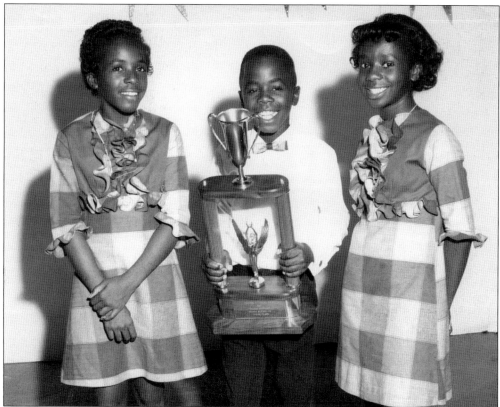

The winners of the 1965 junior amateur division were A. V. and the Avasts, pictured here with their first place trophy. A. V. and the Avasts competed with hundreds of entrants in their division alone.

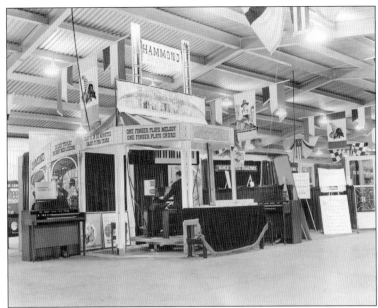

Hammond Organ was one of many vendors in the 1950s. With an organist on-site, it was possible to showcase the company's product. Vendors still take advantage of the opportunity to showcase products at the fair today. (Courtesy Wayne Hunt Photography.)

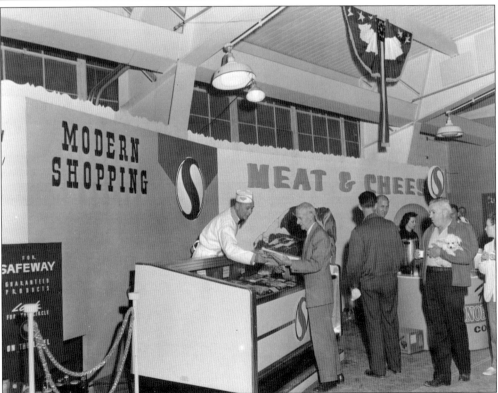

The Education Building was filled with vendors and their products. This 1961 photograph features Safeway supermarket and its meat and cheese section. The opportunity for local businesses to display their products was a major success and opened doors for many businesses. Vendors are placed throughout the entire grounds in order to attract business to their booths. (Courtesy Wayne Hunt Photography.)

Vendors not only included companies selling products, but also businesses advertising services. The Public Service Company (PSO) of Oklahoma displayed models of different rooms in the home and how PSO affected daily life. Companies used the fair as a marketing venue for their new products and services, allowing fairgoers to be the first to see something innovative. (Above, courtesy Hopkins Photography Company; below, Wayne Hunt Photography.)

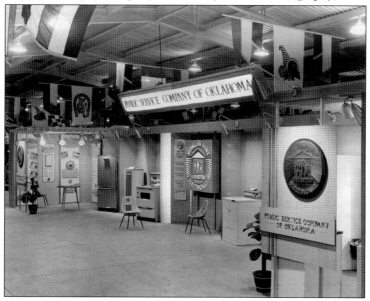

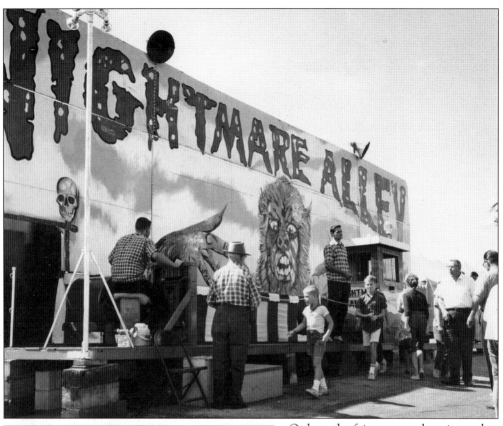

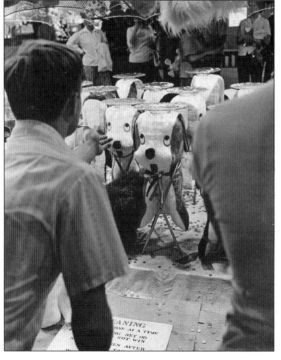

Only at the fair can people enjoy such entertainment as the Spider Lady, the World's Smallest Horse, and in the 1960s, Nightmare Alley. These special shows that highlight oddities have been around the fair for over half a century. Tulsa State Fair visitors have been able to enjoy these fictional scenarios that are brought in by the carnival.

The midway games may be impossible to some, but that is part of the fun. Darts, leapfrog, and the penny toss are all games that bring back memories to fairgoers. Street games were a part of the earliest fairs in the early 20th century. (Photograph by Ben Newby, *Tulsa Tribune*.)

Contestants of the Sooner Princess Pageant ride with Mayor James Maxwell. The Sooner Princess Pageant sold advance tickets and helped promote the Tulsa State Fair.

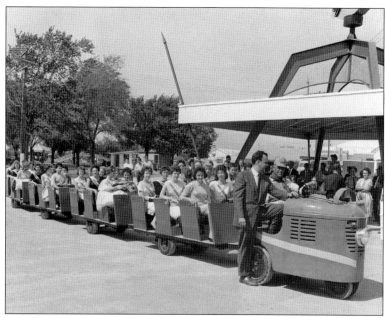

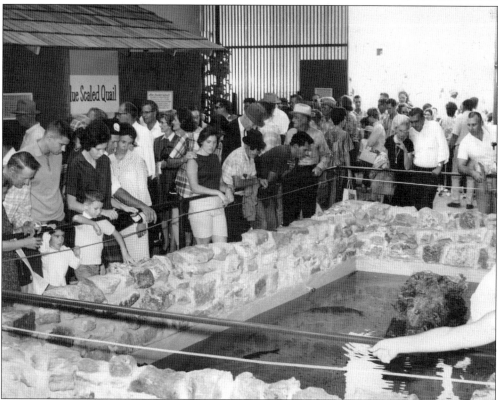

The Wildlife Building was a place that visitors could visit not only during the fair but year-round. The fish tank pictured was just one of the attractions at the Wildlife Building. The state wildlife department staffed this facility and was able to use this as a center for many public displays of different types of creatures in the 1960s.

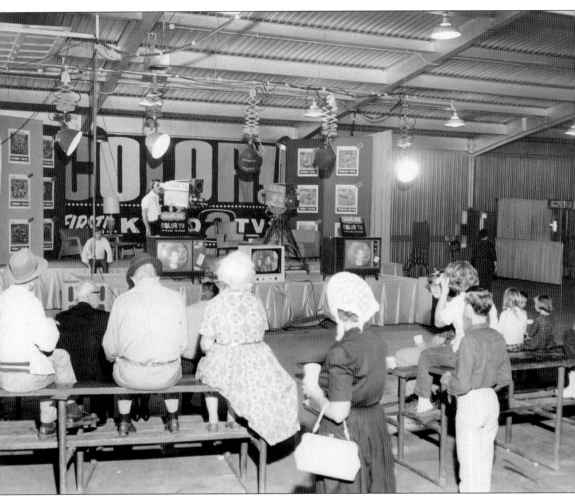

This 1968 KVOO-TV broadcast from the Trade Center featured events going on at the fair. Most television stations would set up their live broadcasts from the fairgrounds. The last of the live television broadcasts took place in 2008. Television stations have moved away from bringing an entire set out to the fairgrounds and now send reporters to communicate the latest fair happenings.

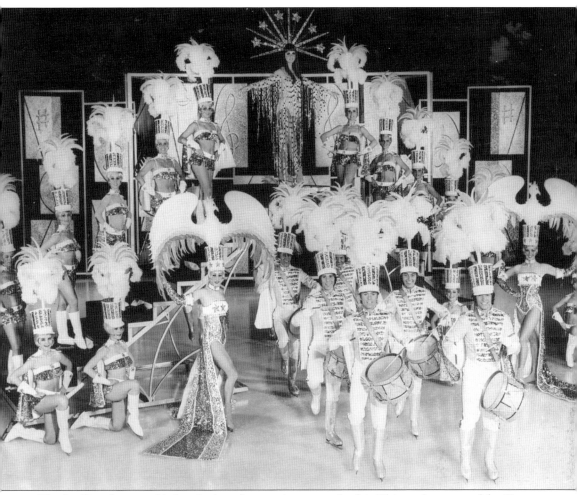

The Ice Capades was added to the list of entertainment at the fair. This performance of the Corps de Ballet's *Say It with Music* took place during the 1973 Tulsa State Fair. The Ice Capades had a long-standing history of exciting and entertaining shows with elaborate costuming. Olympian Dorothy Hamill was also a member of the Ice Capades and owned the show for a period of time during the 1990s. Feld Entertainment became the next form of ice-skating entertainment with the shows Disney on Ice.

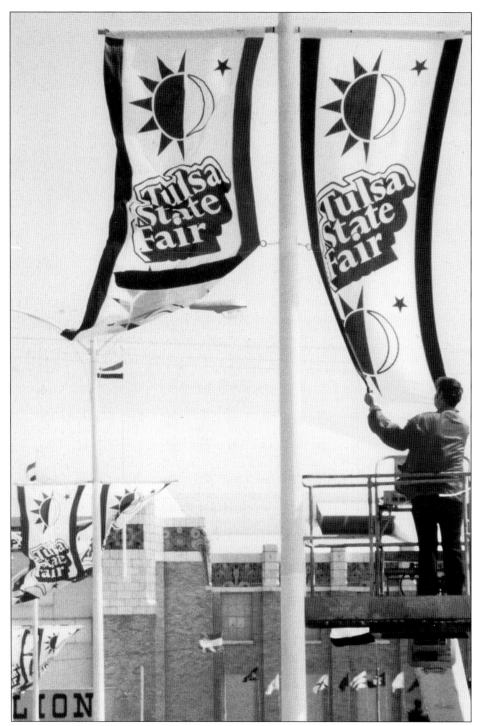

Tulsa State Fair banners are hung here during the fair in the late 1970s. The themes and banners have always played a large role when preparing the atmosphere for the fair and been a key component in decorating the fairgrounds. Production advances have led to the creation of banners that provide fresh and updated looks.

Animals have been a part of the fair since the very beginning. The petting zoos, livestock events, and different animal shows have led to the success of animals being such a crucial part in the fair. This 1980 photograph shows the care a child is taking for her animal in the livestock show. The largest attractions at the Tulsa State Fair usually involve animals. (Courtesy Curtis Winchester.)

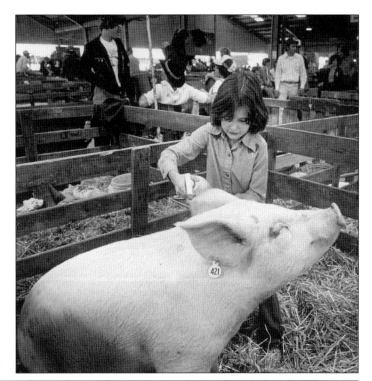

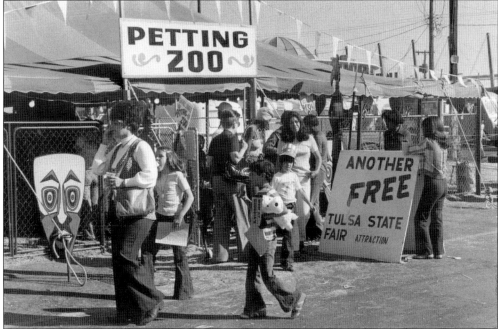

The petting zoo is an event that the entire family can enjoy together. Animals range from pigs and sheep to ostriches and exotic animals that most people typically wouldn't experience being near. The educational learning experience allows adults and children alike to not only interact with the animals, but also gain knowledge of different species. The petting zoo is filled with animals, and each year the variety is different.

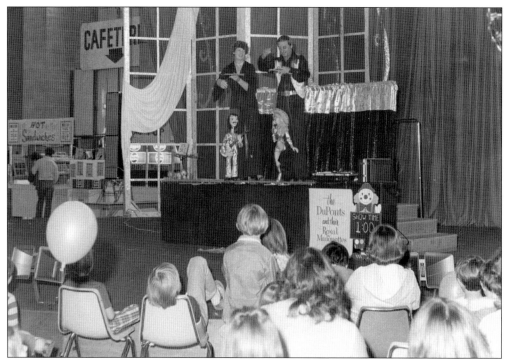

Marionette shows took place in the 1970s and provided entertainment for children. The DuPonts and their Royal Marionettes performed before allowing the children to try to move the marionettes as well. The Tulsa State Fair always emphasizes children's activities. Multiple shows a day give the opportunity for more children to see them. (Below, courtesy Maurice Forrester.)

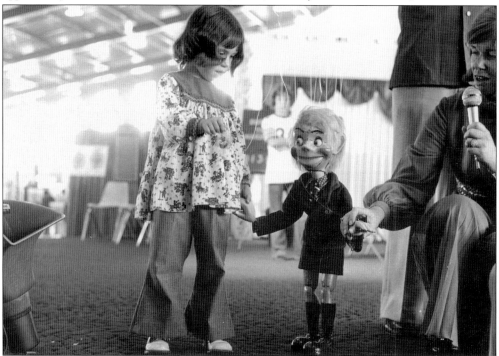

The ice-skating rink was built in 1949 and not only brought shows to the Pavilion, but it also allowed people to come and skate. This early-1980s photograph shows children of all ages playing a game on the ice. The ice rink was also made to be able to switch to a basketball court, rodeo arena, and provide the proper floor for almost any event.

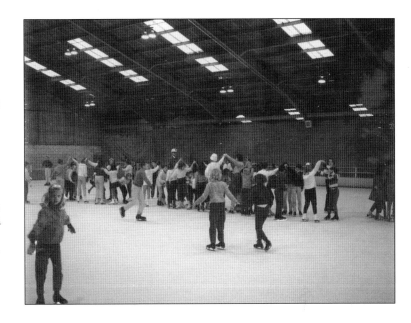

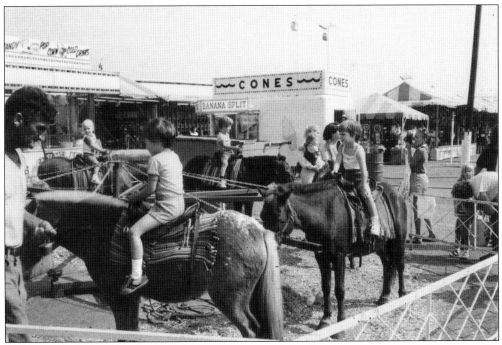

The 1982 midway brought back the continuation of this favorite opportunity, the chance for children to ride ponies. The Tulsa State Fair celebrated its 75th birthday that year and celebrated with a special attraction sponsored by the Diamond Jubilee Commission. This special exhibit featured some of the same exhibits found in the Smithsonian Institution.

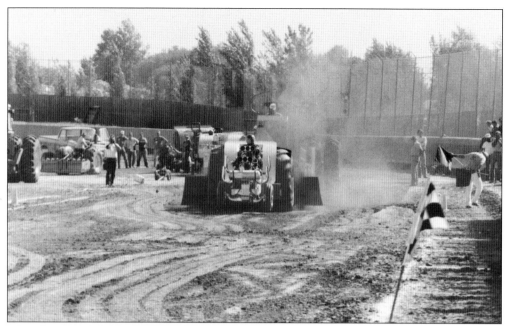

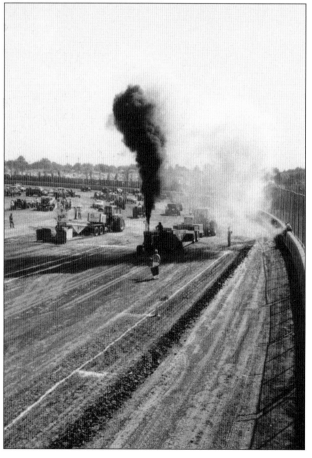

The tractor pull was located along 30 feet of Twenty-first Street and Yale Avenue at the current location of Big Splash Water Park. These 1982 photographs show the races of those competing for thousands of dollars in prize money and bragging rights. Over 20,000 spectators watched these souped-up tractors in action.

The 1983 Ice Capades brought the popular Smurfs to the stage. Other entertainment that year included the Osmond Brothers, Johnny Rivers, Rick Nelson, and even a special appearance by Willy Wonka, who provided an encore appearance with treats and magic for the kids.

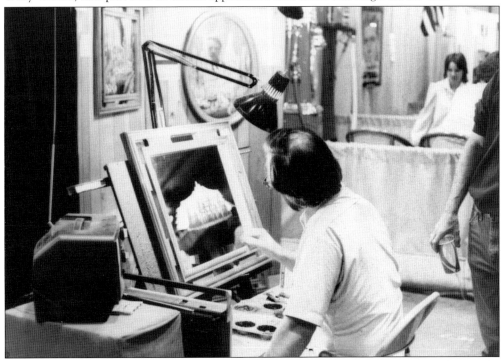

This 1984 vendor paints a picture that he will then try to sell. Artists have found a place at the fair and feature their work to be sold. The arts have also played a large role in the fair's competitive exhibits, which showcase the creativity and capability of the competitors.

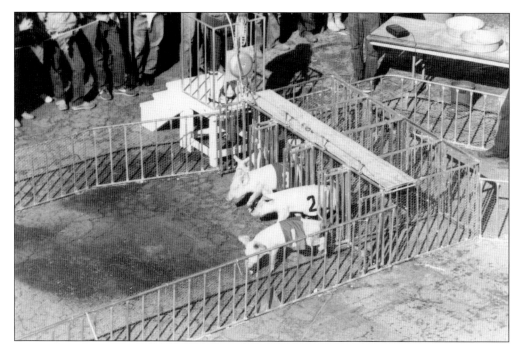

Grounds acts from music to races have always played a large role in the fair entertainment. The pig races are an event that fairgoers are always excited to see. The 1980s photograph above shows little pigs leaving the gate to be the one that receives the Oreo cookie. Today's racing pigs have become accustomed to living in air-conditioning and being adored by fair viewers. Strolling musicians bring the entertainment to the fairgoer. Below, the Jim Herrington one-man band plays and sings to those all over the grounds.

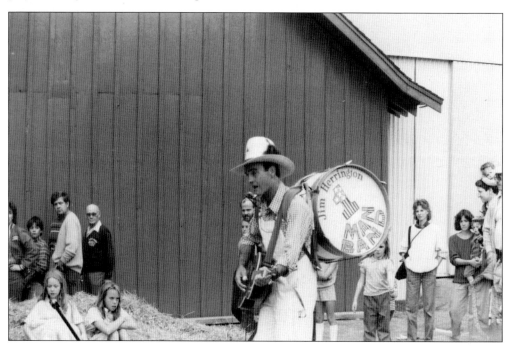

The Coors Cabaret Theater brought in local acts to the stage. The lineup from 1986 included Dottie West, John Conlee, Bo Diddley, Bobby Bare, Three Dog Night, Mitch Ryder, and The Drifters. This free stage brought national acts to the Tulsa State Fair throughout the 1980s. Cabaret Theater entertainers included KGTO's Rock n' Roll Review, Gary Morris, the Bellamy Brothers, the Nitty Gritty Dirt Band, Lacy J. Dalton, The Association, Riders in the Sky, and Atlanta.

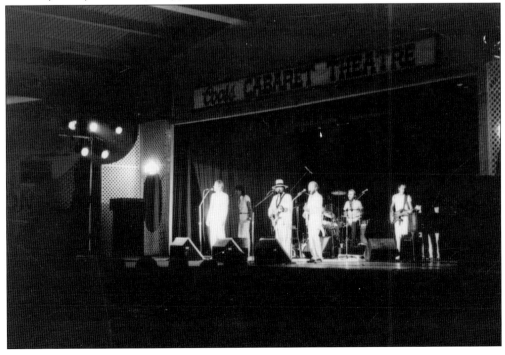

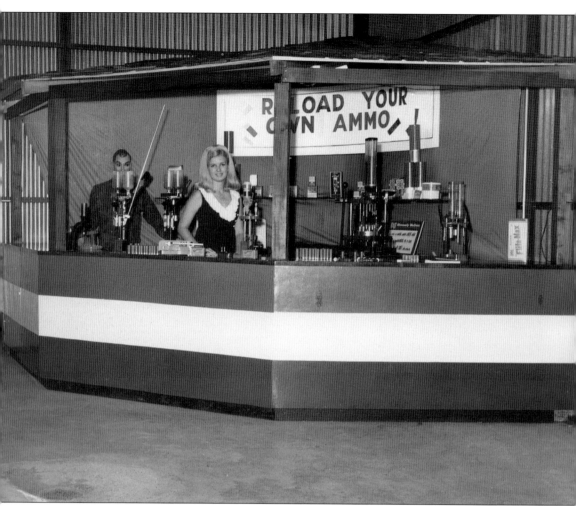

The variety of products sold at the fair is endless, but this late-1970s photograph features an ammunition stand. It is no longer possible to purchase or sell guns or ammunition during the fair. There are multiple gun shows that occur each year at Expo Square, and these shows have to abide by strict rules and regulations.

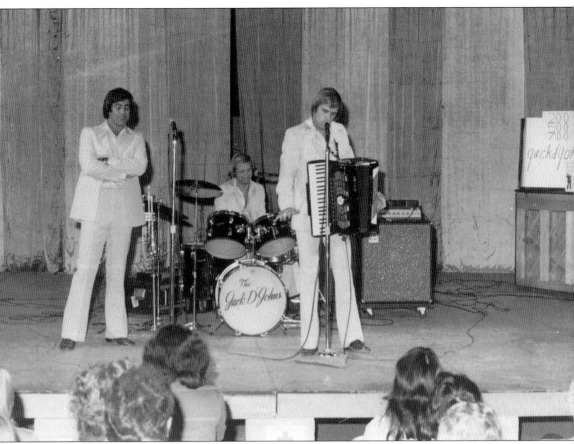

The Jack D'Johns played at the Tulsa State Fair multiple years during the 1980s. The Boston-based group performed to large crowds that gave them such a good review they were brought back several times. The Jack D'Johns brought a show full of music and comedy to the stage. The act made national appearances on television and has performed all over the country. Numerous acts made their way to Tulsa, and the Jack D'Johns were just one of many that have entertained the Tulsa crowds.

Bell's Amusement Park was built in 1951 and was a part of the fairgrounds until 2006. The park was over 10 acres, with 50 rides and attractions on the grounds.

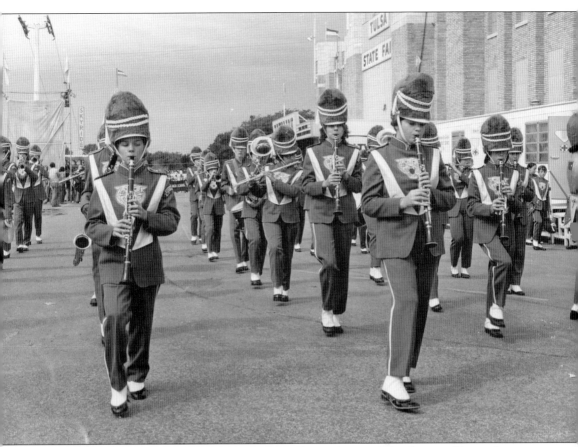

The Tulsa State Fair parade featured bands from all over the city. Schools were able to take part in the annual parade and show off their talents. The Checotah Wildcats perform during the annual parade that took place on the first Saturday of the fair. The Tulsa State Fair parade ended in 2005. (Courtesy Maurice Forrester.)

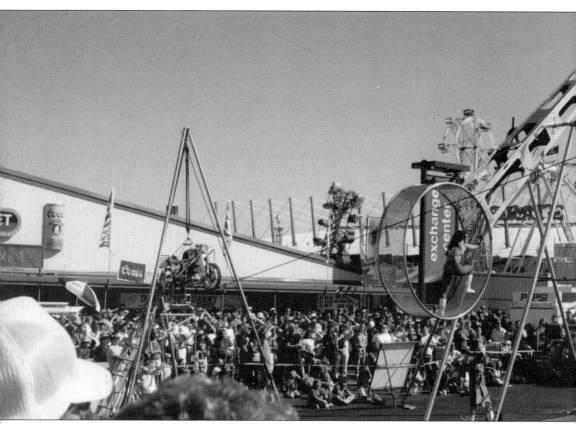

The 1993 Tulsa State Fair brought in new entertainment that featured circus-style acts, adding a new spin on extreme stunts. Different tricks performed included a motorcycle on a wire and a mouse wheel run by the performer. These extreme acts were a large hit with the crowds and also showed the variety the fair had to offer.

Couples who have celebrated over 50 years of marriage are allowed to participate in the Golden Age Celebration. Couples are invited to attend a breakfast that features speakers, gifts, and activities. This special event allows for couples to share the joy that they have experienced with other couples who have achieved the same milestone. As of 2009, this traditional fair activity has been celebrated for 43 years.

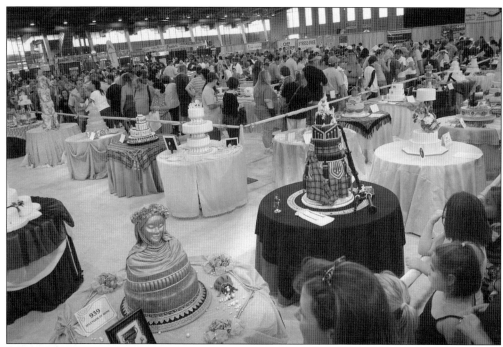

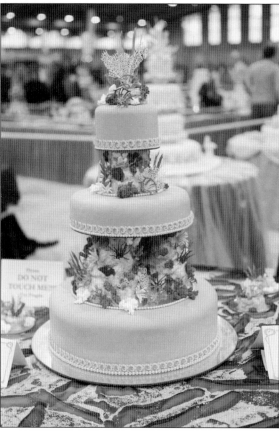

The Oklahoma State Sugar Art Show features top cake artists from all over the nation competing for the grand prize. The competition began in 1993, when renowned sugar art expert Kerry Vincent brought it to the Tulsa State Fair. This has become an annual event that brings spectators out to see the masterpieces created. With the competition receiving national recognition on the Food Network and *Brides* magazine, this has become a coveted competition for cake artists. (Courtesy Cooper Designs.)

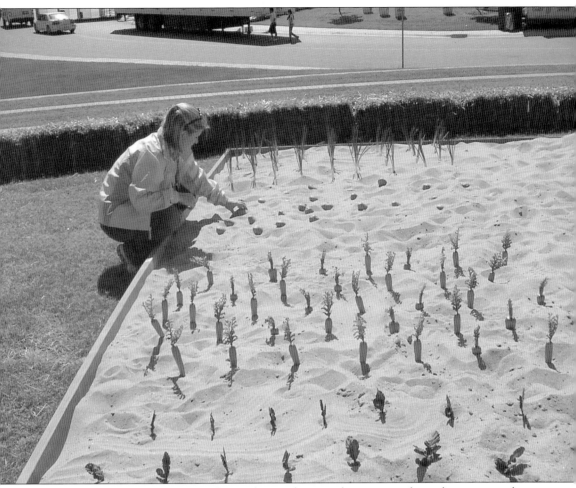

Oklahoma's Largest Classroom (OLC) provides an educational component for students visiting the fair. School groups are invited to participate in activities that give them knowledge of agriculture, science, and other areas. Children learn where their food comes from and how animals are born. In 2009, the OLC program went into its 11th year. (Courtesy Cooper Designs.)

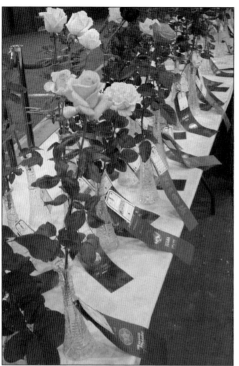

The Tulsa State Fair Rose Competition began in the early 1950s along with the dahlia show. The rose show continues to be a part of the fair each year. With almost 50 classes of roses, the show allows the opportunity to showcase the popular flower that so many have cultivated. (Courtesy Cooper Designs.)

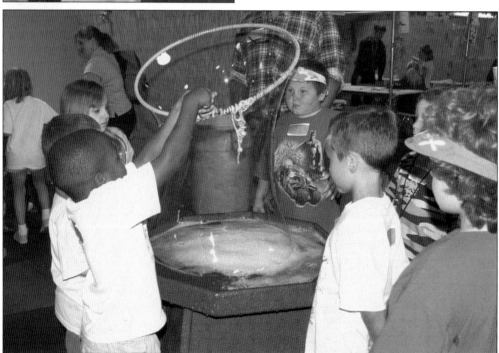

The "Just for Kids" building offers many opportunities for children to not only play, but participate in fun, educational activities while they are at the fair. The "Discovering Science" activity has taken place several times. Different areas are set up for children to participate in hands-on activities that leave them with factual knowledge. (Courtesy Cooper Designs.)

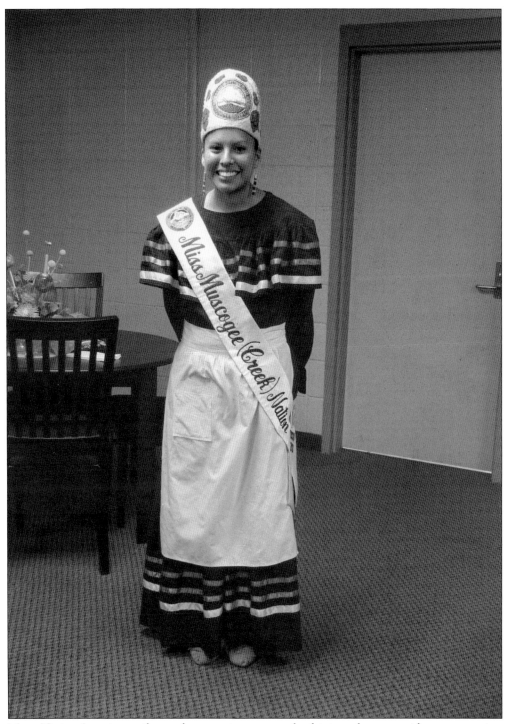

Many Native American tribes make an appearance at the fair in order to provide representation and education on their histories, cultures, and traditions. The 2009 Miss Muscogee Creek Nation Princess was present at the fair and represented her tribe's traditions and activities. (Courtesy Cooper Designs.)

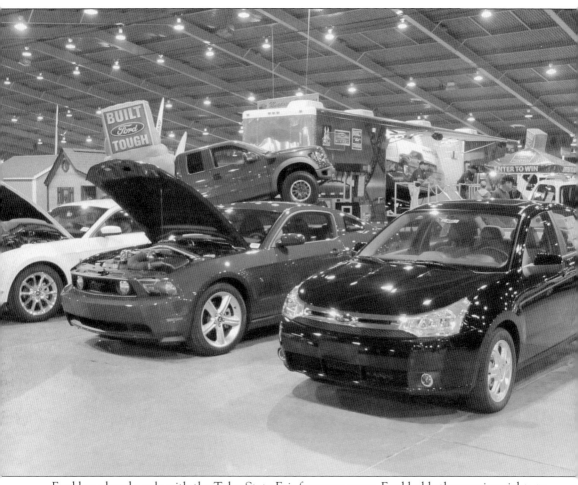

Ford has played a role with the Tulsa State Fair for many years. Ford holds the naming rights to the Built Ford Tough Livestock Complex and is also the presenting sponsor of the Tulsa State Fair. Ford's presence is clearly shown at the fair with its large selection of vehicles, and in 2009 it had the unveiling ceremony for a new 2011 truck model. The Built Tough Ford Livestock Complex is now one of the premier livestock facilities in the nation and holds several of the largest livestock events in the United States. (Courtesy Cooper Designs.)

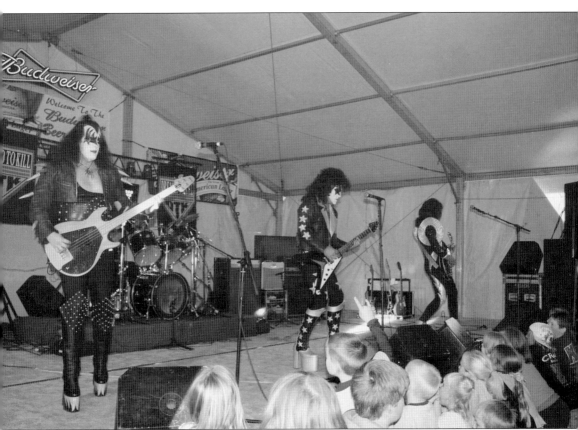

The Budweiser Beer Stage is a premier spot for local talent to perform. The KISS cover band Dressed to Kill is one of the many acts that have played on this stage, which has hosted entertainers of many genres. Regulars on the Budweiser Beer Stage over the years have been the Mid-Life Crisis Band, Bill Davis, and Three Hour Tour. (Courtesy Cooper Designs.)

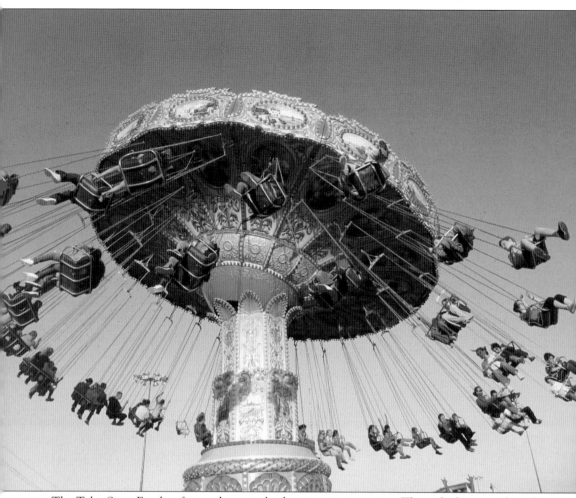

The Tulsa State Fair has featured carnival rides since its inception. Through the years the rides have grown in size, strength, and speed. With rides ranging from the Ferris wheel to the Tilt-o-Whirl, there is never a dull moment on the midway. (Courtesy Cooper Designs.)

Three

LIVESTOCK AND RODEO

From the beginning, livestock and rodeos have played major roles in the Tulsa State Fair. The increasing amount of interest over the years has made this part of the fair not only an educational addition to the fair experience, but it also brings enjoyment and competition.

The livestock portion of the fair was introduced in the early 20th century through such small shows such as rabbit and poultry events. As time progressed, the shows began to gain more attention with entries and overall entertainment. Through school programs such as the Future Farmers of America (FFA) and local 4-H chapters across Oklahoma, participation in the Tulsa State Fair livestock competitions have led to growth in all the livestock areas.

The Professional Rodeo Cowboys Association (PRCA) first attended the Tulsa State Fair in the mid-1980s and continues to this day with events such as bull riding, barrel racing, and other traditional attractions. The Tulsa State Fair holds pride in the rodeo, which has now been to Tulsa for over 20 years. The excitement from the crowds shows how successful the event has become.

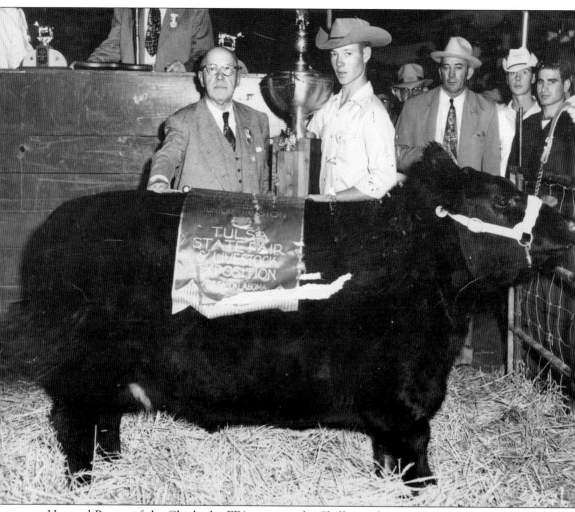

Harvard Brown of the Chickasha FFA receives the Skelly trophy at auction at the 1953 Tulsa State Fair. The Junior Livestock Auction is able to advance students' knowledge and careers by participating in this program. With millions of dollars raised for scholarship, students are able to further their education. Companies and individuals have made contributions to the Junior Livestock Auction. (Courtesy Future Farmers of America.)

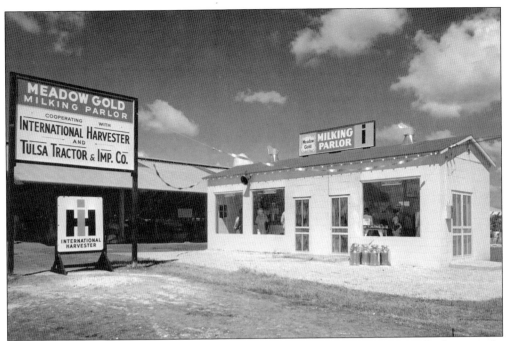

The Meadow Gold Milking Parlor was a full-service milking parlor on site at the fairgrounds, providing fresh milk and also the opportunity to view the process that occurs. The milking parlor returns to the fair each year in order to demonstrate the process that is used. Exhibitors will typically use their cattle for the demonstrations. The milking parlor is not only used as an educational tool, but it is also seen as a convenience for the exhibitors. (Above, courtesy Hawks-Terrell Photography, Inc.; below, Hopkins Photography.)

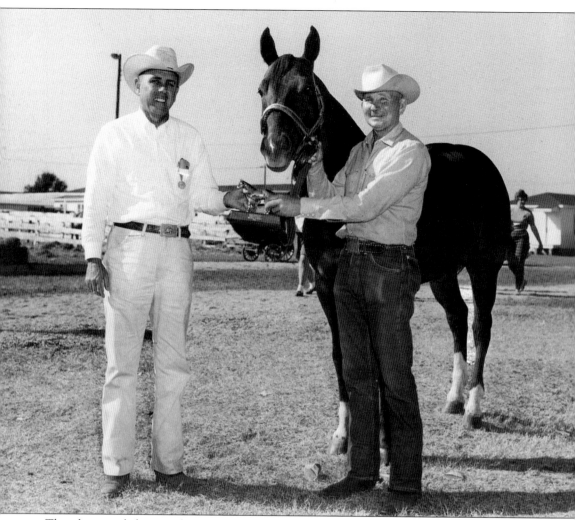

This photograph features the Grand Champion Quarter Horse Stallion, King Bunkie. The horse was shown by Dee Burk (right) of Wagoner, who is shown as he is congratulated by Whit Cox, the quarter horse official and local department store owner. The 1960 Quarter Horse Show was one of many livestock events that occurred that year. (Courtesy Wayne Hunt Photography.)

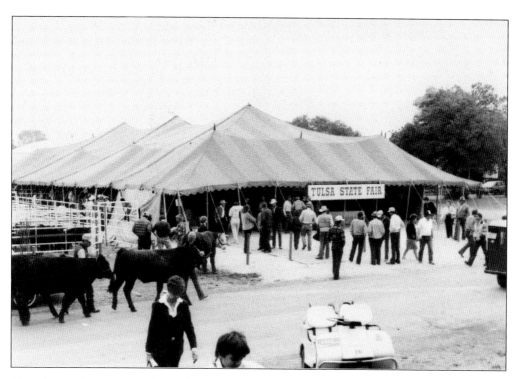

Many livestock events were located not only in the barns but also in tents. Both locations allowed for more competitions and also more space. Both indoor and outdoor competitions allowed for people to participate and also watch the events.

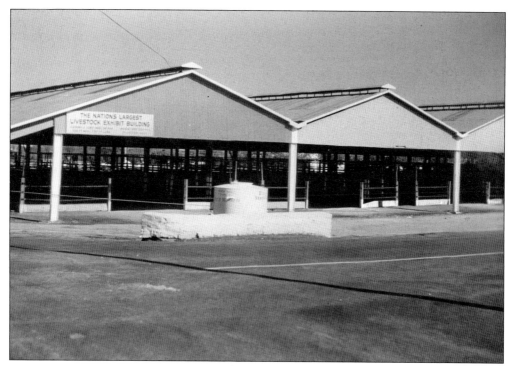

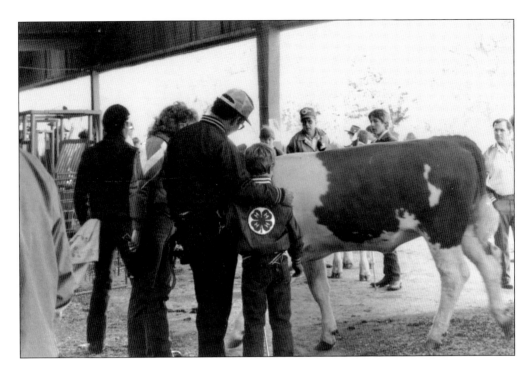

In these images, 4-H students are shown preparing for their competitions. The 4-H has stood for the support of youth development in Oklahoma. Students from all over Oklahoma bring their livestock to competition. The Oklahoma 4-H students focus on furthering their knowledge of the agriculture and livestock areas.

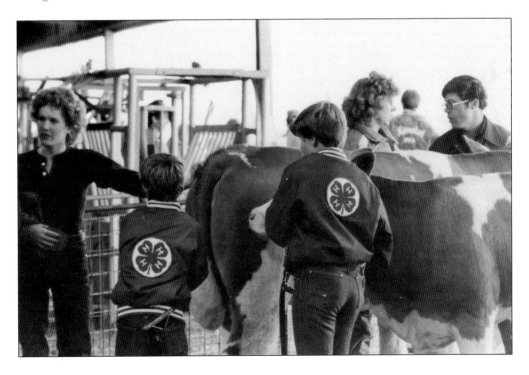

Mrs. Dan P. Holmes congratulates a winner in the 1973 Junior Livestock Show. It takes the efforts of many individuals to put together such an event.

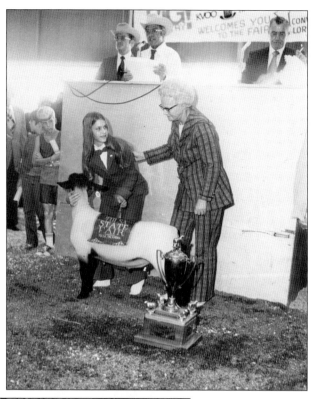

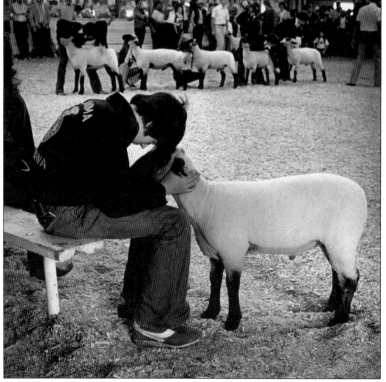

A young competitor prepares for his upcoming show in this 1980 photograph. The attention to detail required by competitors before the actual event is greater than many people realize. Many contestants start at least a week in advance with grooming, and the process to train the animal takes great amounts of time.

A backdrop is set up for pictures in order to have an area for the animal to pose. All champions have their photograph taken, and everyone else has the option to have their photograph taken as well.

This plaque is located in front of the barns and features the contributors' list. The plaque was produced by Ernest Wiemann Iron Works and features the officers, planning committee, and contributors.

The facilities have required maintenance over the years, and in these 1983 photographs FFA members are helping with the upkeep of the barns. Over the years, the facilities have gone through major renovations and new projects, but no matter what the project is there is going to be maintenance that is needed. Local organizations like the FFA have provided contributions, such as painting parts of the barns.

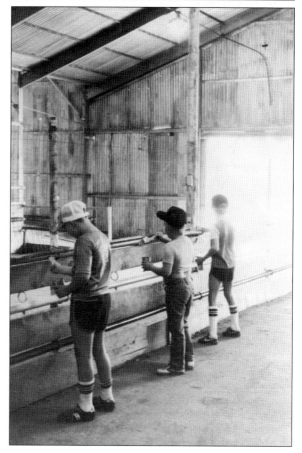

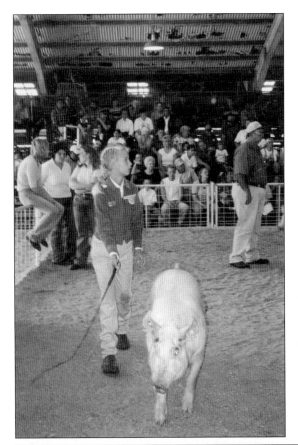

There are many reasons why students compete in the livestock competitions at the fair, but one very important aspect is the overall enjoyment that everyone receives while participating. For many, raising livestock has always been a way of life. Students work hard, but they find the outcome very rewarding. (Both courtesy Cooper Designs.)

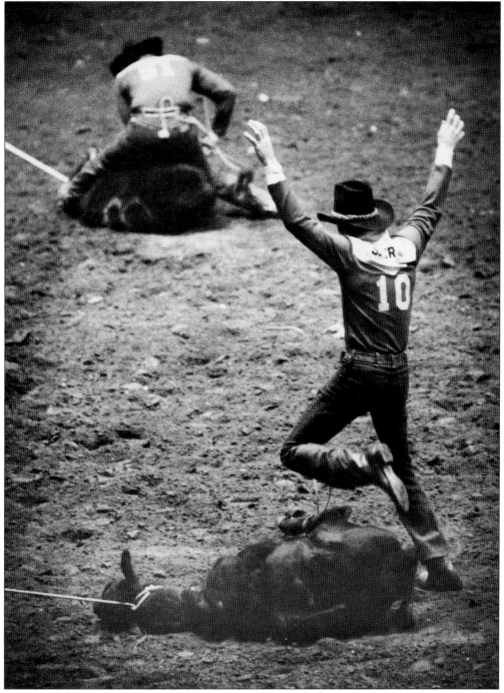

Twister Steve Crow scored a 9.99 in calf roping to beat Amarillo Bill Brecheisen in their matchup. Calf roping is an individual sport and began its appearance at the Tulsa State Fair in the mid-1980s.

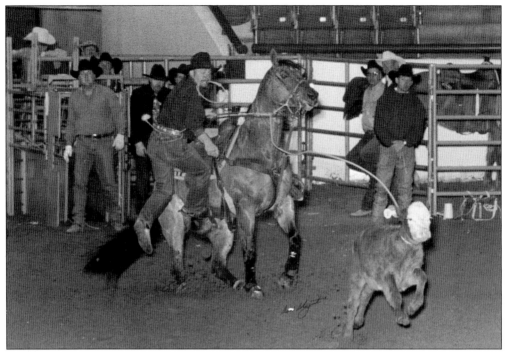

The fair started as a livestock event, but in the mid-1980s, the rodeo brought a new chance for the fair to grow. With six rodeo events, cowboys are able to come to Tulsa to participate in the Professional Rodeo Cowboys Association Rodeo. Each year, the second weekend during the fair highlights the rodeo followed by concerts featuring nationally recognized artists. (Above, courtesy Don Shugart Photography; below, Kirk Voska.)

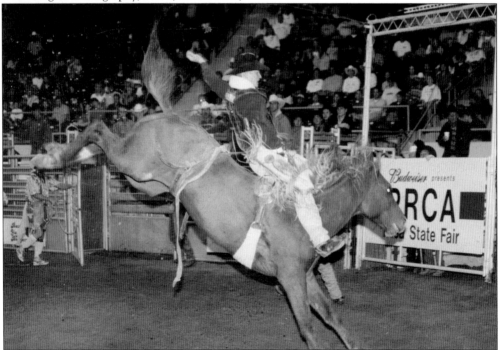

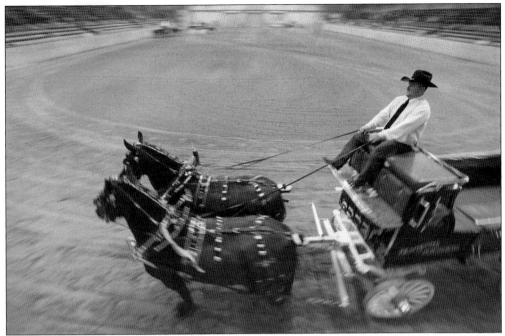

The draft horse hitch driving class makes its way around the Ford Truck Arena during the 2009 fair. With multiple classes, this event is always available to participate in or watch from the side. (Courtesy Cooper Designs.)

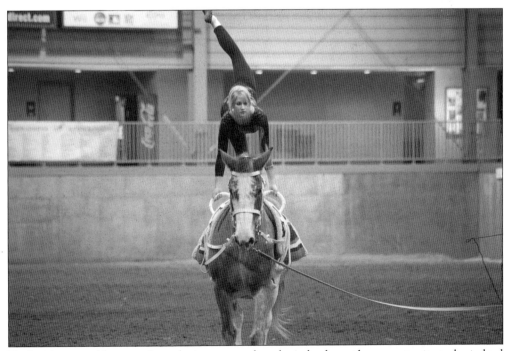

Trick riders are able to perform during events, but they also have the opportunity to be judged on their ability. This 2009 photograph shows a judged performance of a trick rider. (Courtesy Cooper Designs.)

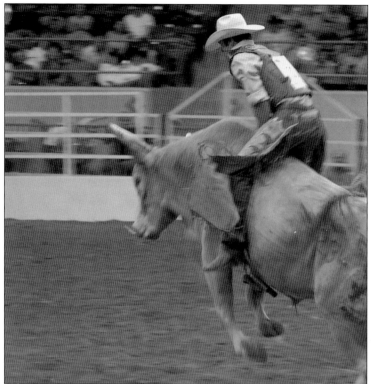

Bull riding is one of six events that the PRCA Rodeo brings to the fair. Bull riding typically brings 5 to 10 entries in a particular category, and riders compete two of the three nights during the rodeo. Bull riding was included when the rodeo was brought to the fair in the mid-1980s. (Courtesy Cooper Designs.)

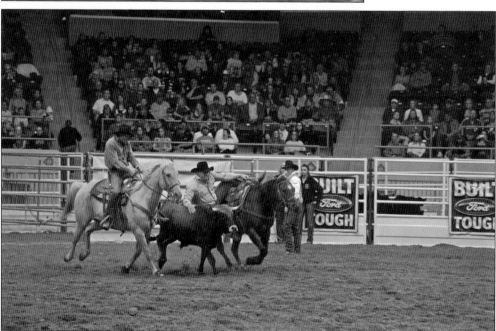

Steer wrestling is a timed event that requires the cowboy to line up his horse with the steer. He then grabs the steer's horns, digging his feet into the ground to turn and lift the steer and bring it to the ground. It is often called the big man's event because of the strength that it takes to bring down the steer. This competition came to the fair in the mid-1980s. (Courtesy Cooper Design.)

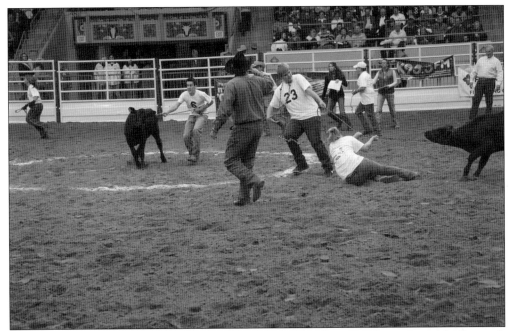

The calf scramble is an annual event that gives students the chance to participate in the livestock area. Ten children from 12 to 18 years of age are chosen each night to participate in the event. Five winners will receive an $800 certificate that can be used to purchase a heifer. These students write monthly reports on their experiences and money spent. The next year, students will then be able to show their heifer at the fair. (Courtesy Cooper Design.)

Rodeo clowns have the job of being funny, but their primary concern is ensuring the safety of the cowboys. The rodeo clowns use their own skill and knowledge to distract the bulls after cowboys have fallen. (Courtesy Cooper Design.)

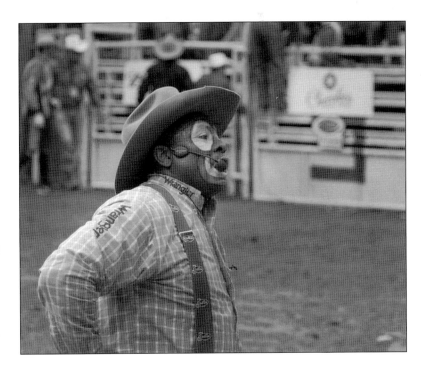

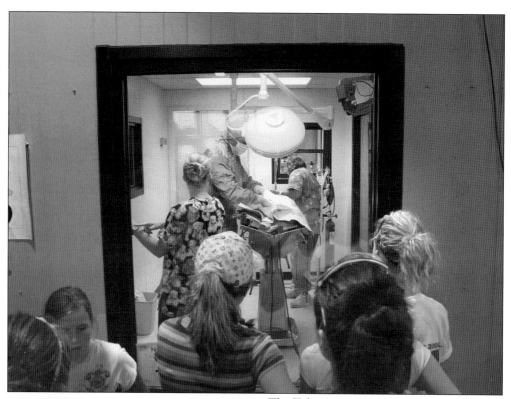

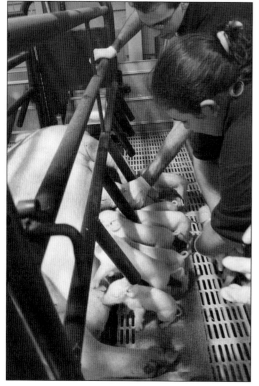

The Tulsa State Fair livestock department gives the public the opportunity to observe the process for animal surgeries as well as animals giving birth. Veterinary clinics bring their patients in for surgeries, and poultry, swine, and sheep are used at the birthing center. The birthing center allows fairgoers to see the care taken for both the mother and the babies before and after birth. (Courtesy Cooper Design.)

Four

THROUGH THE YEARS

The Tulsa State Fair has a long-standing history and many traditions that have carried on throughout the years. The changes that have been made were done in order to improve the fair that has become one of the top fairs in the nation. From the buildings to the entertainment, there have definitely been additions and changes in many areas. Looking back on what these changes have been is always exciting and clearly shows the changes during the eras.

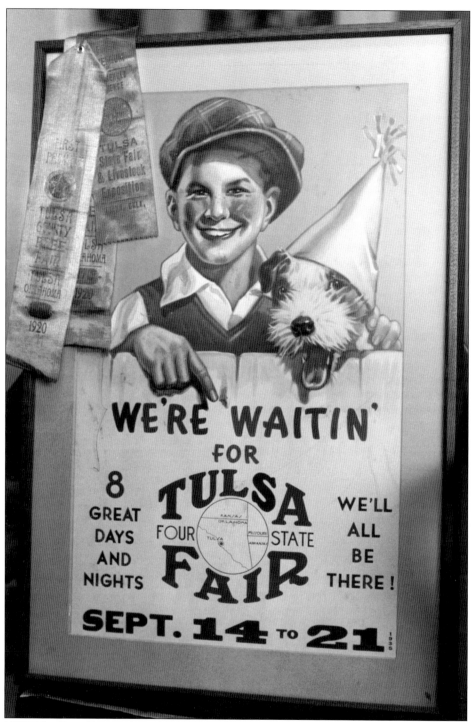

A 1935 Tulsa State Fair poster is shown along with ribbons from the 1920 fair. The 1935 fair was a landmark fair due to a legislative act that provided a mandatory appropriation of $25,000 annually by the county commissioners for the premiums. This eliminated the free gate and required an admission fee to paid in order to generate additional revenue.

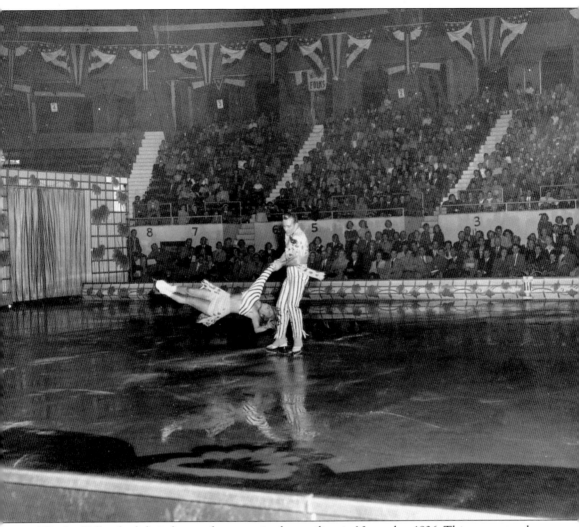

The Ice Follies had their first performance in the pavilion in November 1936. This was not only the first performance that Tulsa had seen, but it was the first performance of the Ice Follies ever. Tulsa was in the middle of a polio epidemic during this time period, but for those who made it to the pavilion for this performance, it was definitely the beginning of a new form of entertainment. The Ice Capades took over in 1940, and this 1949 photograph displays the show during a period of time that was down due to the economic downturn during World War II.

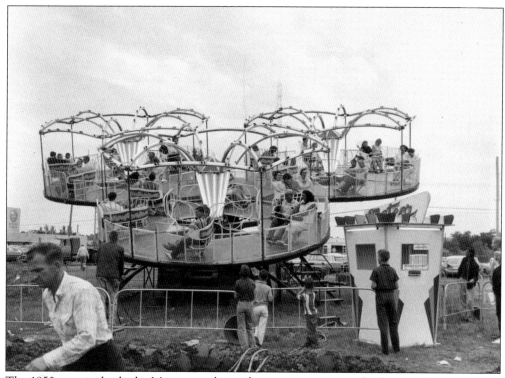

The 1950s carnival ride the Meteor was located on a grassy area on the fairgrounds.

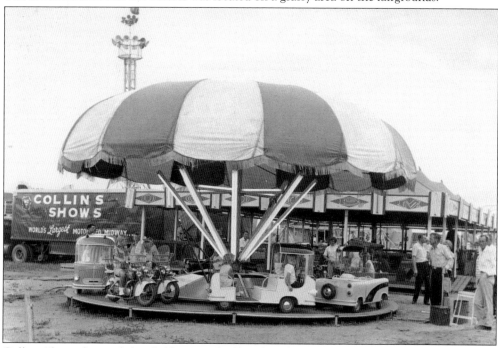

Collins Shows featured the children's umbrella ride. The ride featured a wide variety of colors and had transportation vehicles such as the police car, motorcycles, buses, trucks, and scooters. Topping this ride is a large red and white umbrella.

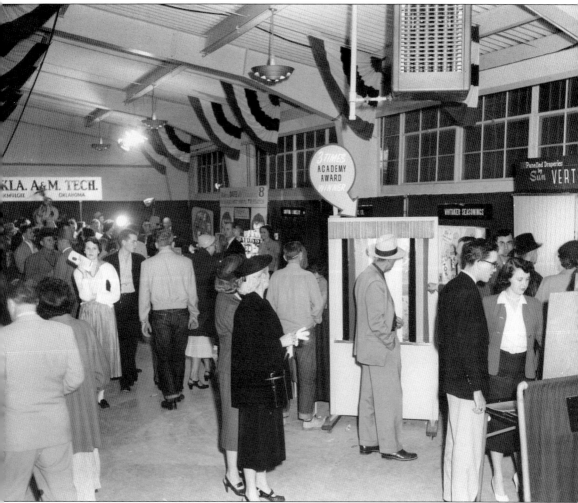

The 1954 "Made in Oklahoma" show featured products and services that were produced in Oklahoma. The "Made in Oklahoma" show still occurs at the fair and is always a favorite of fairgoers. Products range from beef jerky to hot sauce, and the building hosts representatives from the companies that sell the products. (Courtesy Hopkins Photography.)

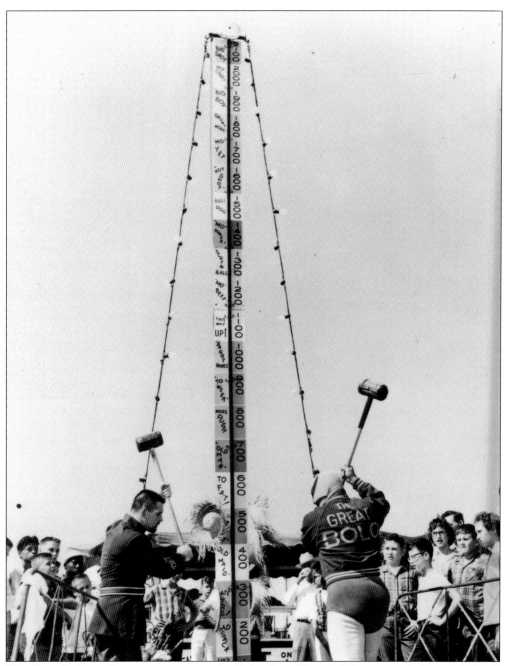

The Great Bolo made an appearance at the Tulsa State Fair while he was with Leroy McGuirk Productions. Appearances were made through the years from multiple celebrities that varied from the Lone Ranger to Playboy Playmates.

Competitive exhibits have always played a part at the fair and continue to entertain the crowds. These photographs were entered in the 1956 photograph competition by H. A. Gotthold. Photography was one of the many categories that could be entered, and winners received ribbons along with prize money.

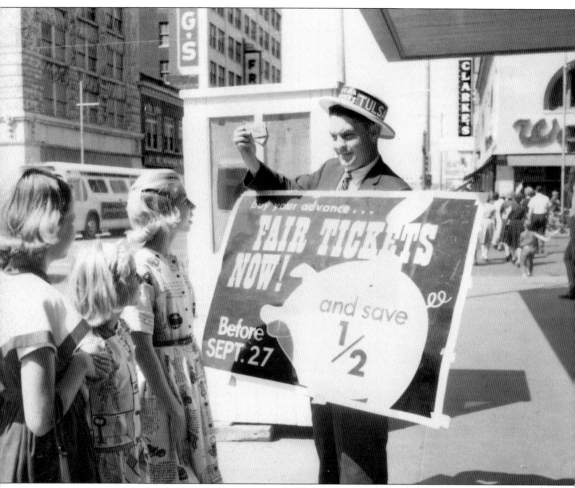

Advertising for the fair has always been present. This 1950s photograph shows a man advertising advance ticket sales in downtown Tulsa. Modern advertising has expanded into television, radio, traditional and electronic billboards, and print. The outlets that are available for advertising have progressed tremendously since the 1950s.

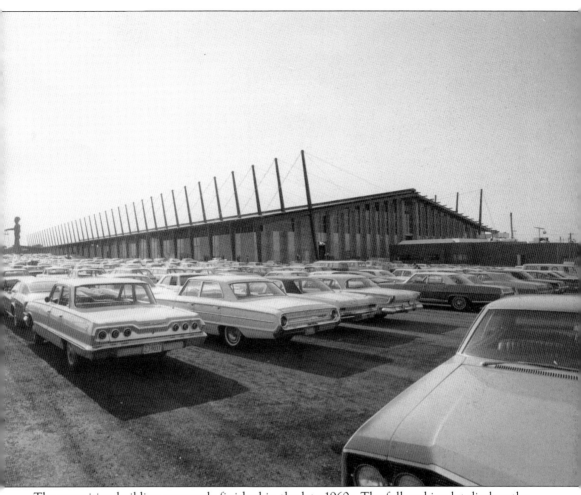

The exposition building was newly finished in the late 1960s. The full parking lot displays the large number of those who attended the events. The opening of the Exposition Center was only more of an incentive for fairgoers to attend the fair.

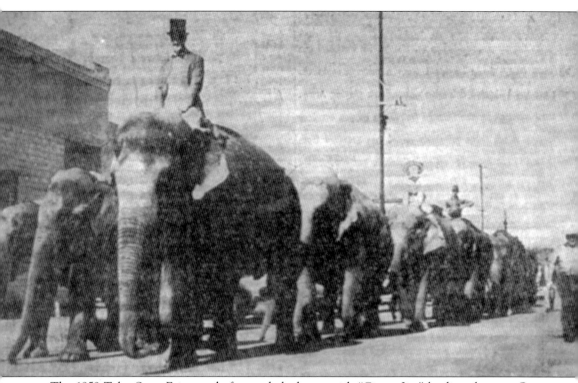

The 1959 Tulsa State Fair parade featured elephants with "Circus Jim" leading the way. Over the years, the parades have varied in talent and style. The earlier parades featured more animals and even in some years a circus theme. In later years, vintage cars and even golf carts were used. (Courtesy Richard Hackll.)

Preparation for the fair in the early 1950s is pictured here. The pig has been the unofficial mascot of the state fair since the early 1950s. The animal was used in all of the Tulsa State Fair advertising throughout the 1980s and most of the 1990s. An official mascot for the fair will be released prior to the 2010 fair.

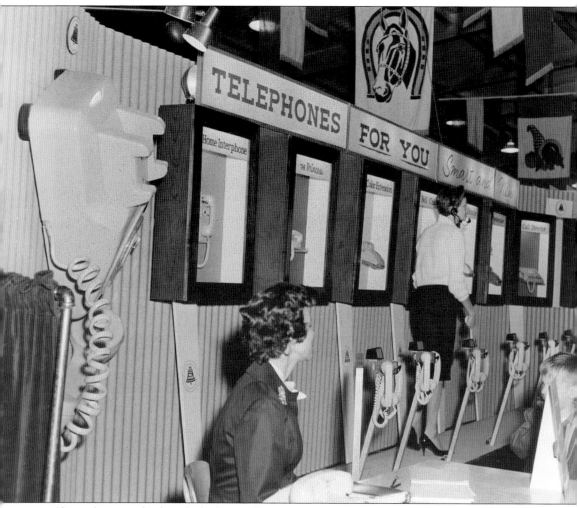

Shown here is a display of telephones that were available for purchase at the Tulsa State Fair. A few styles included the Home Interphone, the Princess, Color Extension and the Call Director. Telephone companies still come to the fair, but now they are advertising cellular telephones and their high-tech features. (Courtesy Wayne Hunt Photography.)

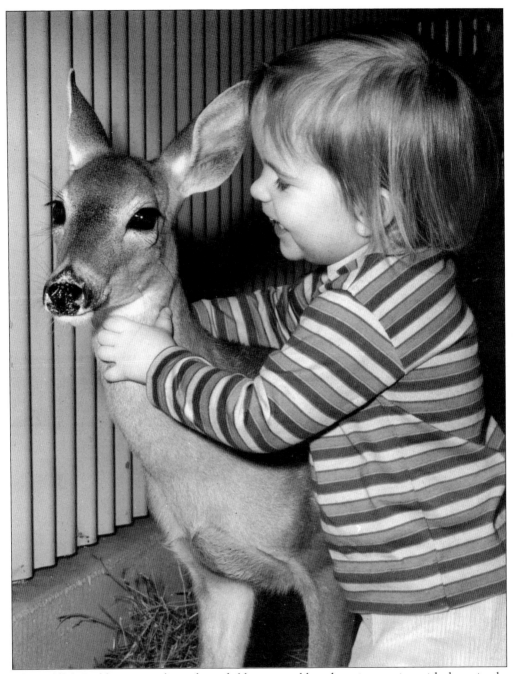

The Wildlife Building was a place where children were able to have interaction with the animals. The Wildlife Building was not only an entertaining aspect of the fair, but it was an educational experience as well. This 1968 photograph shows a young child's experience.

The Tulsa Exposition Center and International Petroleum Exposition signs were placed on the grounds in 1971. A brief overview is highlighted as well as the names of employees, members, and donors.

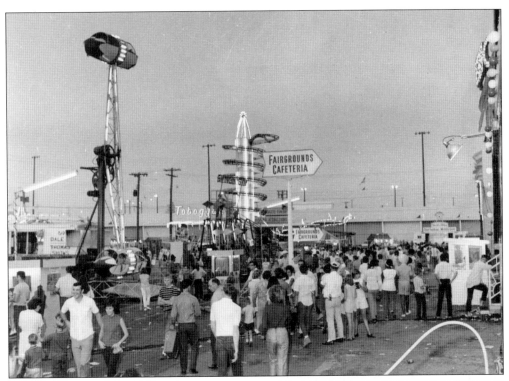

The focal points of the 1969 midway were the swinging gym and the fairgrounds cafeteria. Dale Thomas Shows brought the attractions to the fair and included the toboggan ride as well as many others. (Courtesy Bill Akers Photography.)

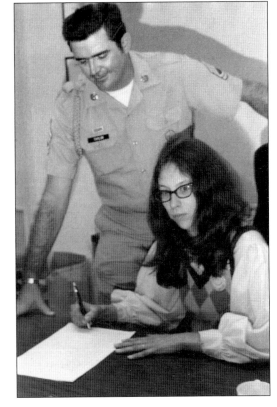

This 1972 photograph shows a young woman enlisting in the military. The armed services attend the Tulsa State Fair in order to recruit and also educate fairgoers about the military.

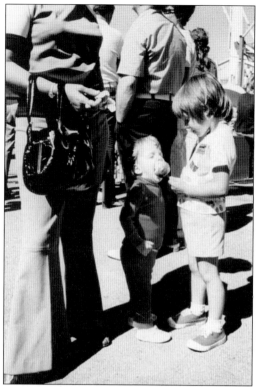

Caramel apples are always a fair favorite. Fair foods are a large part of the experience, and new foods gain new popularity each year. In 2009, there were over 160 food vendors present at the fair who provided a wide variety of offerings. (Courtesy Maurice Forrester.)

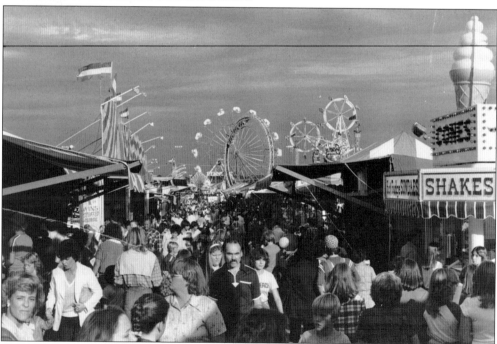

A photograph of the midway in the 1970s shows a large crowd in attendance. Each year during the 1970s and 1980s brought more than one million people out to the fair. The largest attendance came in 1978, when there were 1,361,547 fairgoers.

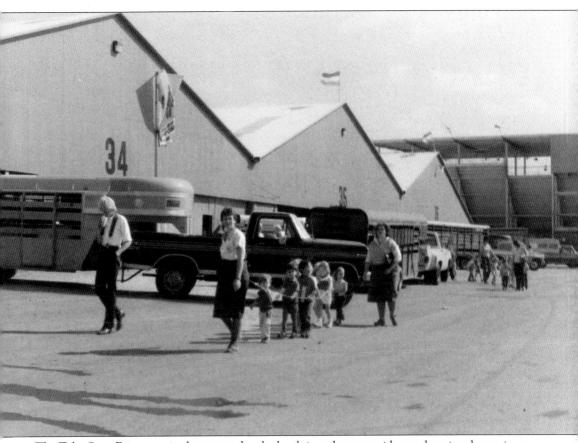

The Tulsa State Fair opens its doors up to local schools in order to provide an educational experience along with lots of enjoyment. This 1983 photograph shows schoolchildren being guided by their teachers as they walk past the livestock barns. Students are able to attend the fair before gates open and make their way around the grounds.

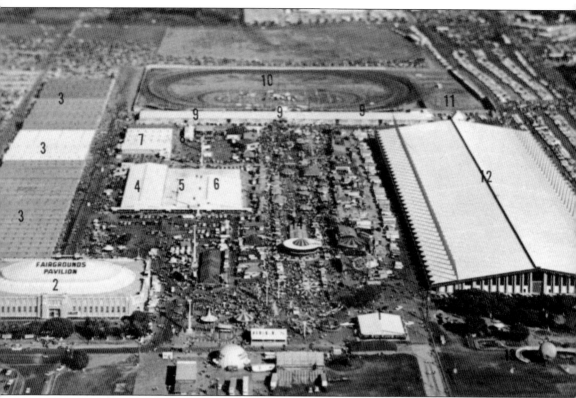

This postcard marks the locations of buildings on the fairgrounds in the mid-1970s: (1) administration office; (2) Pavilion; (3) cattle barn; (4) dormitories; (5) Women's Building; (6) Education Building; (7) Stockman's Cafeteria, poultry, rabbits, children's barnyard, wildlife buildings; (9) general exhibits; (10) race track; (11) office building; (12) Tulsa Exposition Center; (13) Bell's Amusement Park; 14) radio station.

The entertainment at the fair varies from year to year. Each year, animal exhibits are a huge hit with fairgoers. Over the years, everything from sea lions, trick dogs, monkeys, big cats, animals from the outback, and a large number of reptiles have been to the Tulsa State Fair.

Here is another example of the attention that the animal exhibits bring to the fair. This 1991 advertisement shows entertainment options for the upcoming fair.

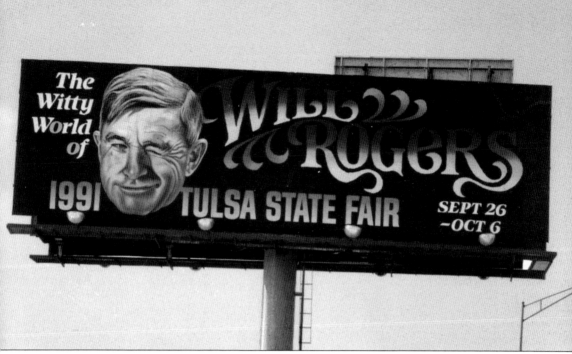

In 1991, the Witty World of Will Rogers highlighted the Oklahoma native. Special artifacts were displayed throughout the fair, and an actor was brought in to put on a special Will Rogers show. The fair was able to draw attention to the career that brought the Oklahoman to stardom and showcase his talent.

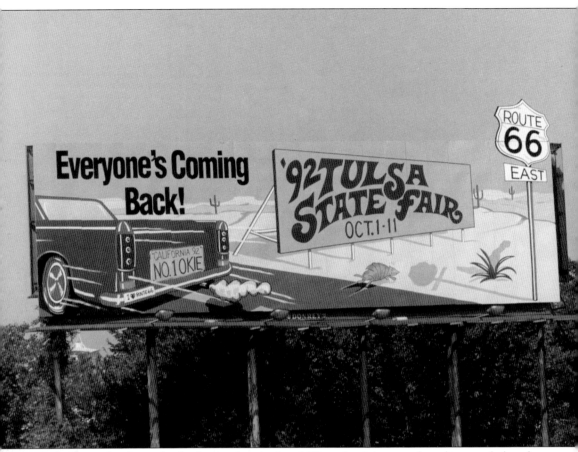

Each year the theme for the fair is advertised on billboards, giving people a glimpse of what they can look forward to seeing.

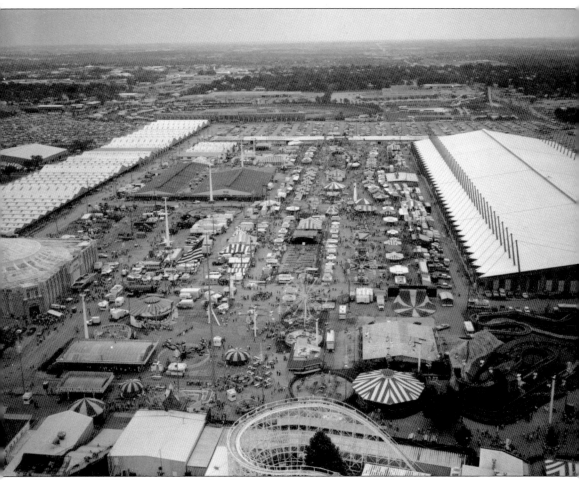

The flood of 1986 brought over 25 inches of rain to some parts of Tulsa. This photograph shows the industrial midway right before the rains began. Fairgoers left early as the rain continuously came down. Exhibitors left in the middle of the fair due to the lack of fairgoers, and multiple buildings leaked. The grounds did not flood, but the continuous rain caused damage throughout the entire fair.

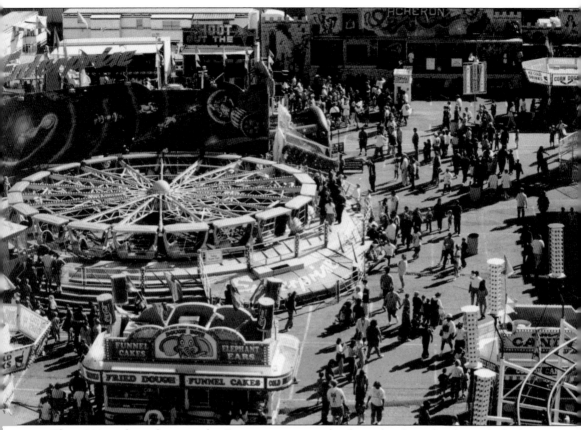

The 1993 midway features the Enterprise carnival ride and a funnel cake and elephant ears stand.

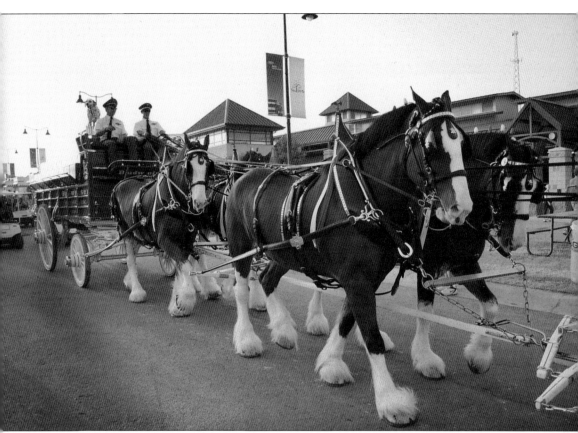

The Budweiser Clydesdales make an appearance at multiple cities each year. This 2006 photograph shows some of the top horses in the nation in the Tulsa State Fair parade. The Budweiser Clydesdales have been around for over 75 years and have made multiple appearances at the Tulsa State Fair. (Courtesy Cooper Designs.)

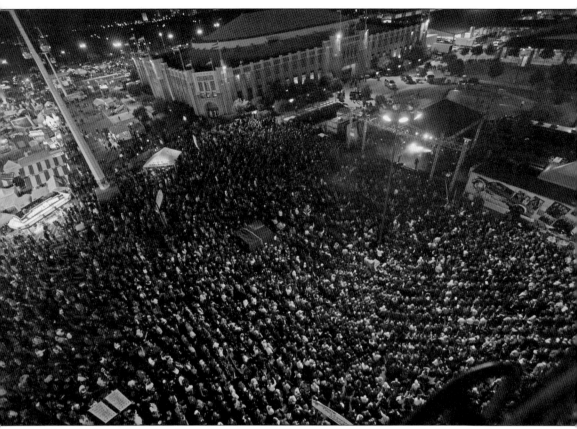

The Oklahoma Stage has featured many nationally recognized music artists. In 2009, the alternative-rock group Shinedown brought a crowd that lined the middle of the midway. The cold weather didn't stop the fans as they packed the area. In 2006, actress/singer Raven-Symoné brought record numbers to the Oklahoma Stage. (Courtesy Cooper Designs.)

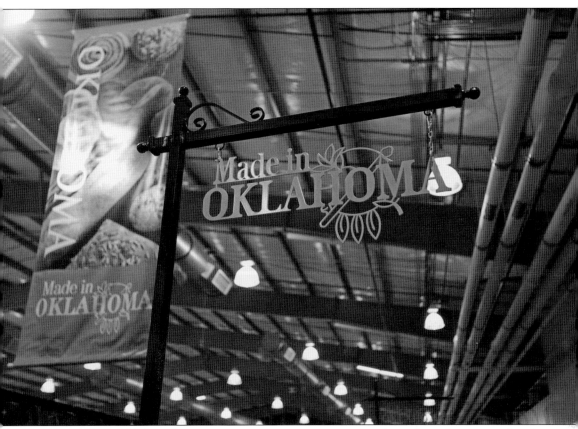

The "Made in Oklahoma" area continues to attract customers with products that are produced in Oklahoma. The "Made in Oklahoma" area was placed in the brand-new Exchange Center in 2008 and remained in that location for the 2009 fair. With shopping and food, this is always a favorite with visitors. (Courtesy Cooper Designs.)

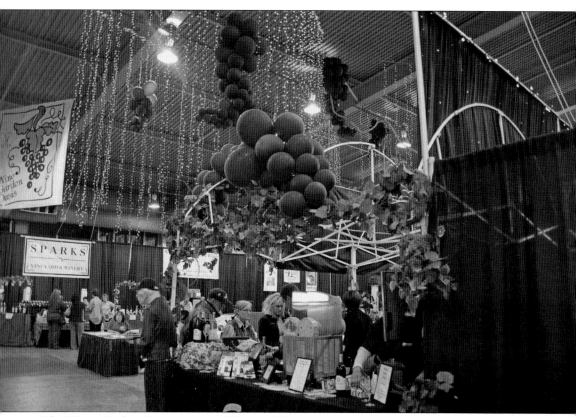

The Wine Garden Oasis features different Oklahoma wineries and their products. Guests are able to enjoy samples of wine while listening to live music. This is not only an enjoyable activity for adults, but it allows the Oklahoma wineries to feature their products and the business that is done within their home state. (Courtesy Cooper Designs.)

Five

NOW AND THEN

The Tulsa State Fair has been a Tulsa tradition for years, and a way of life for people who attended the fair as children later take their own children. The fair has had many different changes through the years, but many things have stayed the same. The modernization of equipment, technology, and safety features has allowed for the fair to be able to keep up with the times and still provide quality family entertainment.

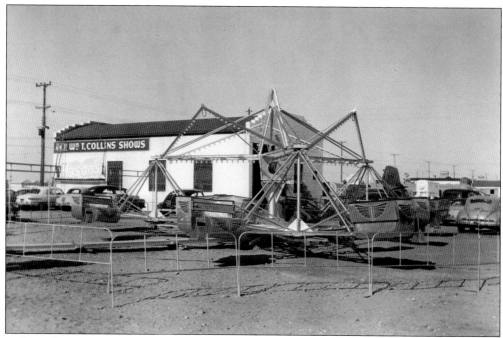

T. C. Collins Shows provided carnival rides for many years in the earlier days of the fair. Today Murphy Brothers Spectacular Attractions provides carnival rides and games throughout the midway. One thing that stays the same from year to year is the enjoyment that these bring to the entire fair. (Below, courtesy Cooper Designs.)

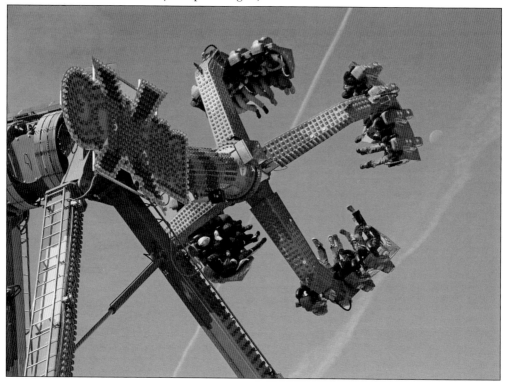

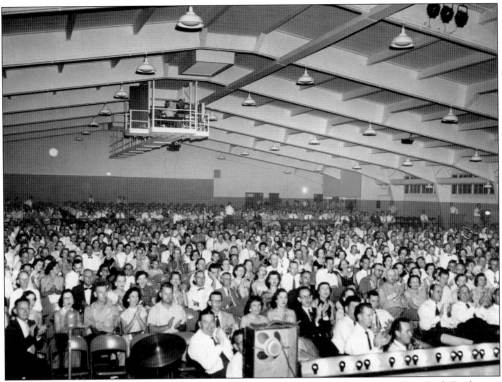

The original Exchange Center was rebuilt and completed right before the 2008 fair. Both Exchange Centers were used for not only the fair, but year-round activities as well. The new building was placed in the same location as the old Exchange Center, which was built in the 1950s. (Above, courtesy Wayne Hunt Photography; below, Cooper Designs.)

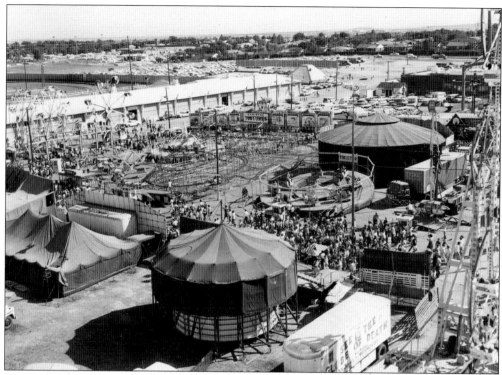

The mid-1960s photograph above and the 2009 photograph below show the changes that have been made over the years. The midway layout changed through the years, along with updated rides and attractions, but there will always be a midway filled with entertainment for everyone. (Below, courtesy Cooper Designs.)

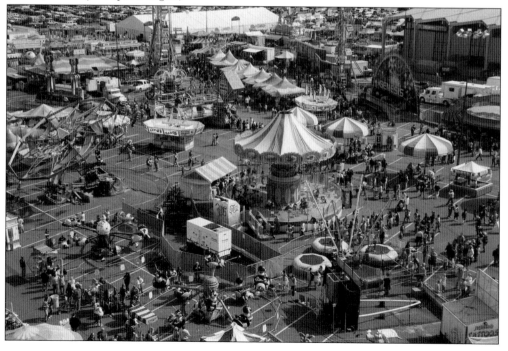

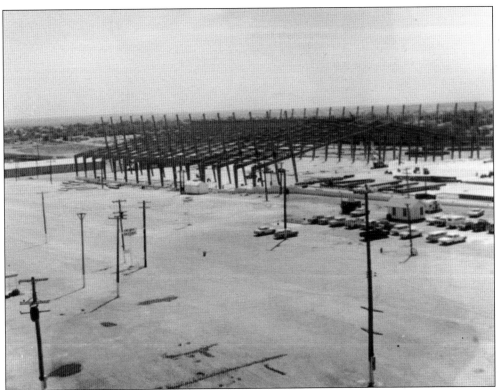

The 1965 photograph above shows the early construction of the International Petroleum Exposition. The 2009 photograph below shows the completed and renovated QuikTrip Center in 2009. The IPE left the grounds in 1980, and in 2007 QuikTrip purchased the naming rights to the building. The QuikTrip Center remains as one of the top facilities in the nation. (Below courtesy Cooper Design.)

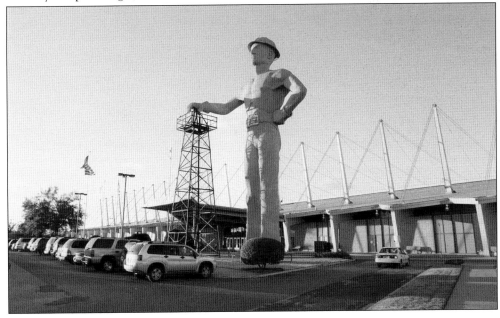

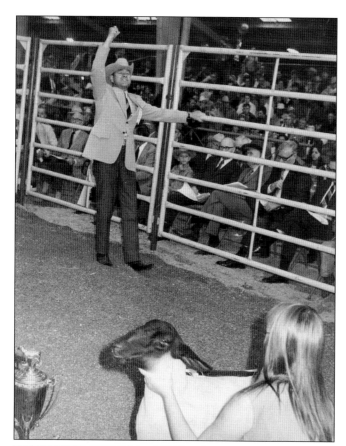

The Junior Livestock Auction always features an auctioneer to run the event. Its auctioneers and ringmasters are professionals who have been in the business for years, and they volunteer their time to help the kids participating in the event. (At left, courtesy *Tulsa Daily World*; below, Cooper Designs.)

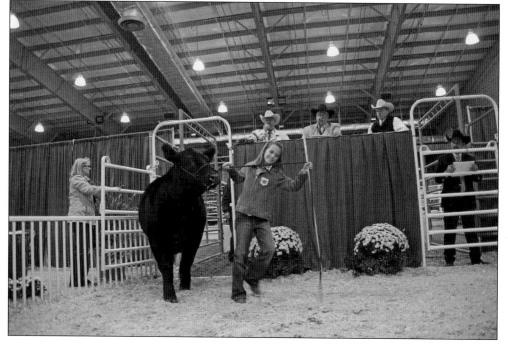

In 2009, the Miss Tulsa State Fair Pageant marked its 39th year as a preliminary pageant for the Miss Oklahoma Pageant. The pageant is free for the public to attend and allows fairgoers to see the possible candidate for Miss Oklahoma. (Below, courtesy Cooper Designs.)

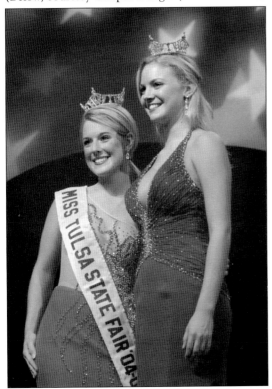

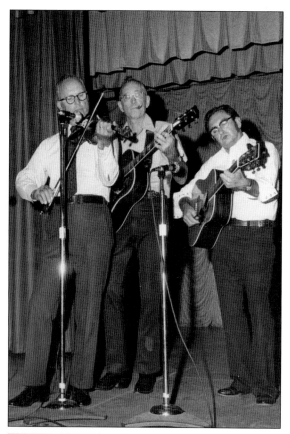

The photograph at left shows Herman Johnson on the left and Mark O'Conner on the right. The Oklahoma State Picking and Fiddling Championships will have its annual event at the Tulsa State Fair for the 38th year in 2010. This annual event features people of all ages competing in categories such as fiddle, mandolin, flat-picking, fiddle-style guitar, and banjo. The 2010 contest will feature the banjo contest, which will be a brand-new addition. Contestants work towards cash and prizes and the title of champion. (Below, courtesy Cooper Designs.)

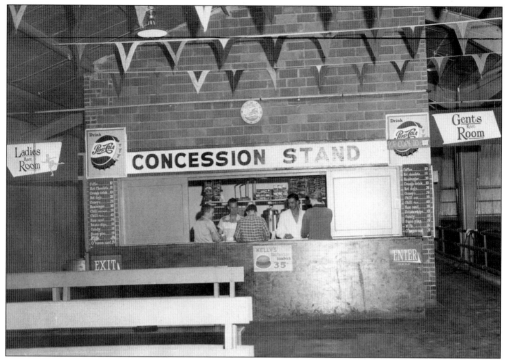

This 1950s concession stand was located in the livestock barn. Menu items ranged from 10¢ orange drinks to 15¢ Bama pies. The modern-day concession stands are located in the QuikTrip Center, Central Park Hall, Ford Truck Arena, Pavilion, and Exchange Center. Each concession stand features many of the same items that were served in the early concession stands, such as hamburgers, hot dogs, and candy. (Above, courtesy Wayne Hunt Photography; below, Cooper Designs.)

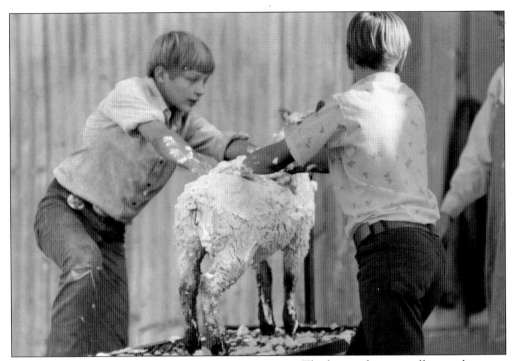

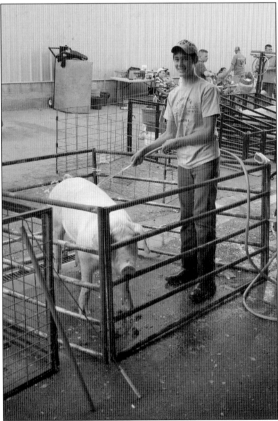

The livestock events allow students the opportunity to show the knowledge they have gained not only in showing their pigs, but how they care for their animals in preparation. Most animals are groomed on-site before the competitions begin. (At left, courtesy Cooper Designs.)

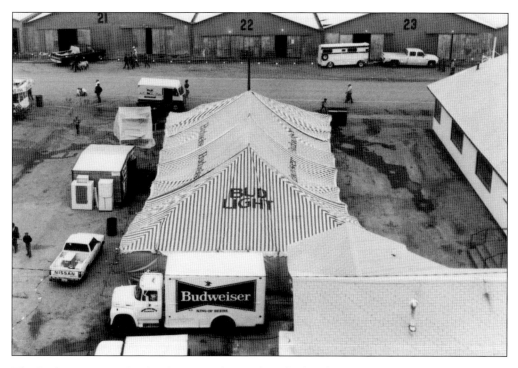

The Budweiser Beer Garden has served as a place for local entertainment and where people can go to sit and enjoy the fair atmosphere. The beer garden has also featured watch parties for different sporting events, which most often is football. Located on the midway, the beer garden gives people a place to rest and enjoy free entertainment. (Above, courtesy Expo Square; below, Cooper Designs.)

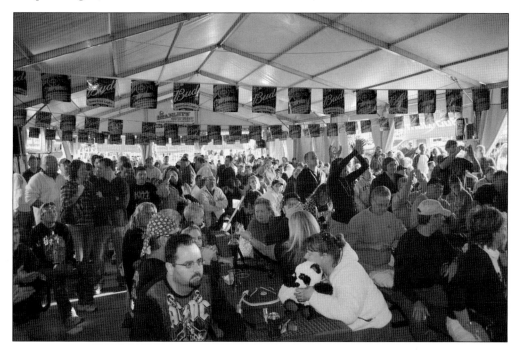

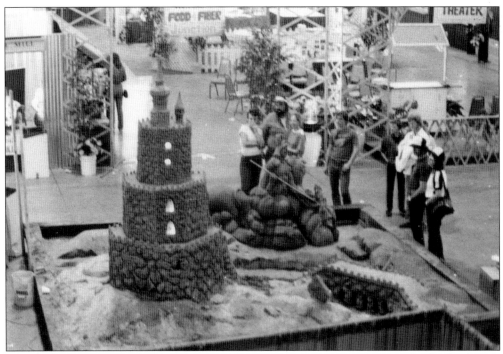

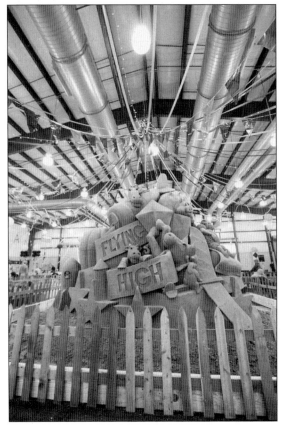

A unique opportunity for the fair has become the sand sculptures that are produced by sand sculpture artists. Pieces over the years have ranged from giant sand castles to fair-themed creations. These different sculptures are constructed during the first part of the fair and then left up for the duration of the fair for people to enjoy. (At left, courtesy Cooper Designs.)

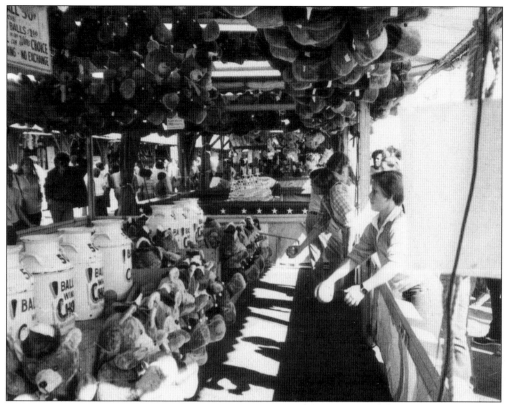

The carnival games have been around since nearly the beginning of the Tulsa street fairs in the early 1900s. The chance to win has entertained fairgoers for over 100 years. (Below, courtesy Cooper Designs.)

Commercial exhibitors are a major reason why many people come to the fair. With a wide variety of products and services, people are able to shop from vendors all across the nation and many times see products that are hard to find anywhere else. (Below, courtesy Cooper Designs.)

The children partner up during a field trip to the fair. Schools all over the area are able to come and participate in educational activities. The Tulsa State Fair places a large importance on educating the public, especially the children, who attend the fair. (Below, courtesy Cooper Designs.)

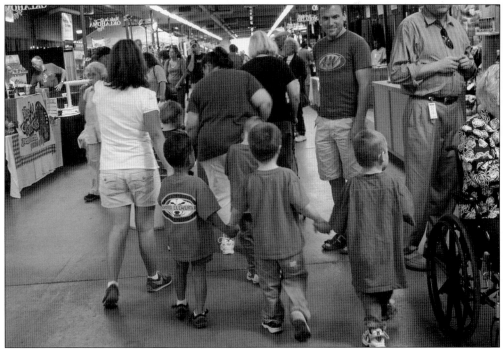

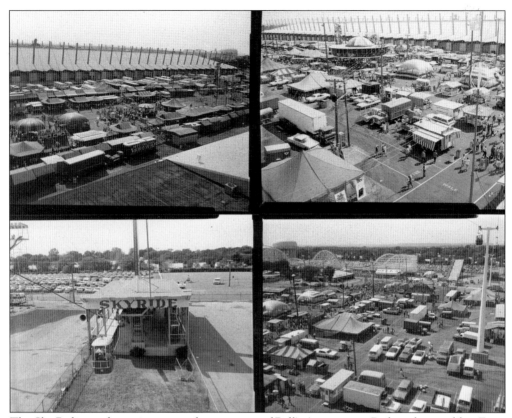

The Sky Ride is a classic attraction that was part of Bell's Amusement Park and was sold to Expo Square in 2006. The Sky Ride takes riders above the midway and to the other side of the park. The Sky Ride was built in the 1960s, and the design was so new that a consultant was brought in from Germany in order to work on the new technique of a continuous cable for the ride. (Below, courtesy Cooper Designs.)

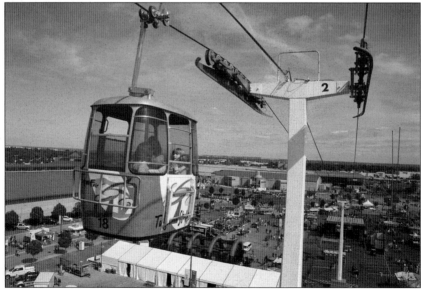

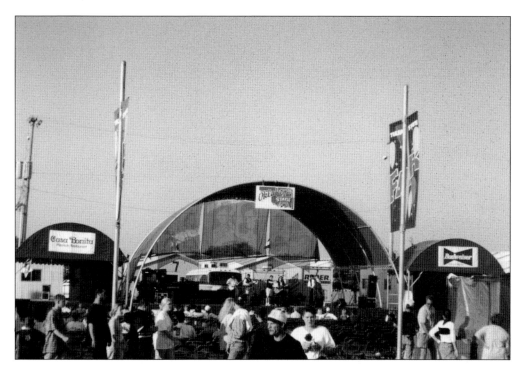

The Oklahoma Stage first debuted in early 1980s and continues to be the main entertainment stage at the fair. Entertainers Everclear, Boyz II Men, Kansas, Shinedown, and the Charlie Daniels Band were all performers from 2007 to 2009. The Oklahoma Stage became the main stage when the cabaret theater became the "Just for Kids" building. (Below, courtesy Cooper Designs.)

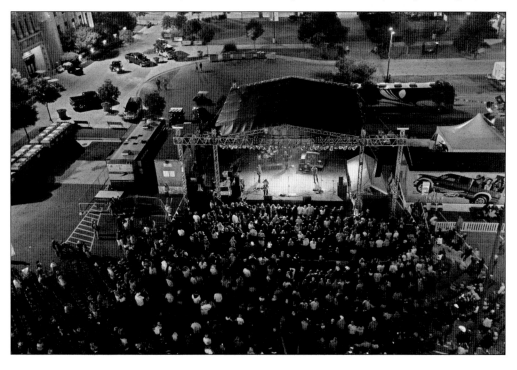

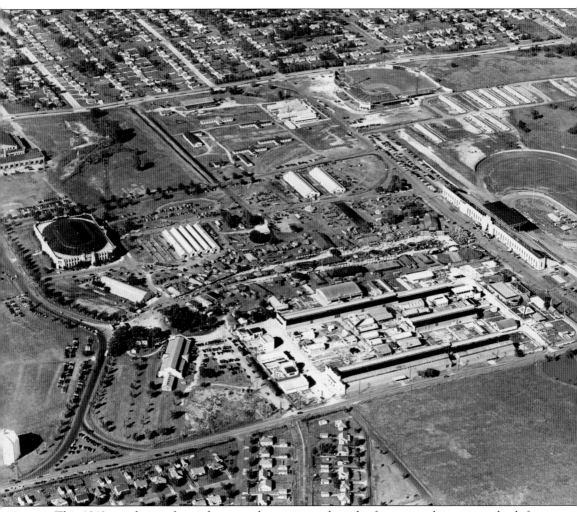

This 1949 aerial view shows the grounds at a time when the fair was making a comeback from economic depression. A new board was in place, and improvements were made throughout the entire grounds that increased fair attendance dramatically. From 1949 to 1958, attendance jumped from 150,000 to more than 600,000. (Courtesy Aerial Photo Service.)

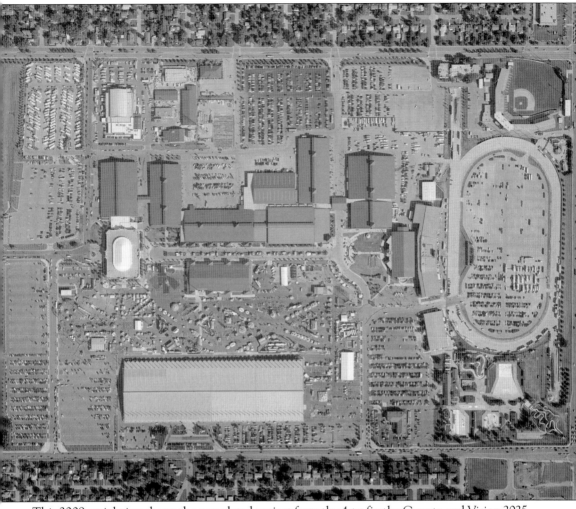

This 2009 aerial view shows the completed project from the 4-to-fix the County and Vision 2025 programs. The project was completed in September 2008 just in time for the fair. The 2009 fair brought over 835,000 attendees to the park, and increases were shown in ExpoServe concessions, independent concessions, ride commission to Tulsa County Public Facilities Authority, and Sky Ride sales.

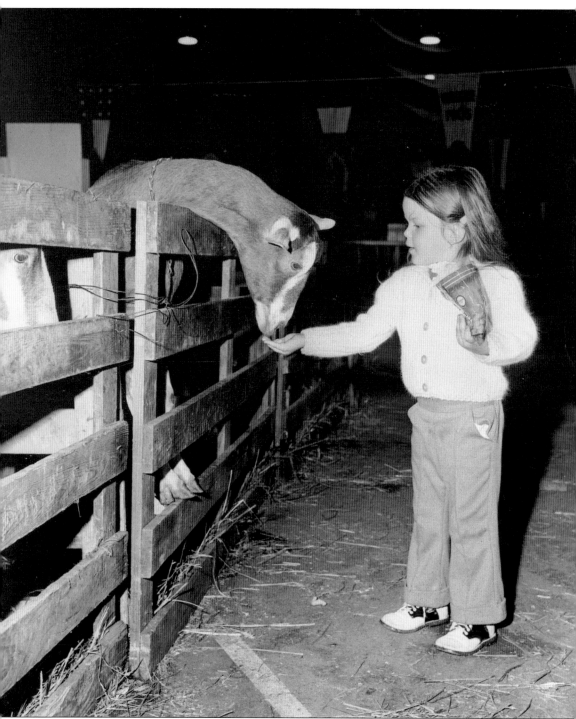

The stated mission of the Tulsa State Fair is "to produce a state fair annually which educates and entertains fairgoers through exhibits, entertainment, history and economic stimulus." The goal each year is to follow these criteria to produce the best fair possible for Tulsa. (Courtesy Maurice Forrester.)

The fair brings out the young and young at heart to enjoy the tradition of the Tulsa State Fair. From the beginning of the street fair in 1903 to one of the largest fairs in the nation, the Tulsa State Fair has become the largest event in Tulsa that focuses on the family. (At right, courtesy Herald Giulus; below, Richard Pulliam.)

The Tulsa State Fair begins the fourth Thursday after Labor Day and runs for 11 days. This time is filled with activities and events that are meant to keep everyone busy. (At left, courtesy Maurice Forrester; below, *Tulsa Daily World*.)

A family of four leaves the Tulsa State Fair.

www.arcadiapublishing.com

Discover books about the town where you grew up, the cities where your friends and families live, the town where your parents met, or even that retirement spot you've been dreaming about. Our Web site provides history lovers with exclusive deals, advanced notification about new titles, e-mail alerts of author events, and much more.

Find Your Place in History.